AMERICA'S WORDS of FREEDOM

Speeches, Documents, and Writings
That Moved Our Country

Ideals Publications
Nashville, Tennessee

ISBN-13: 978-0-8249-5904-3
ISBN-10: 0-8249-5904-3

Published by Ideals Publications
A Guideposts Company
535 Metroplex Drive, Suite 250
Nashville, Tennessee 37211
www.idealsbooks.com

Library of Congress Cataloging-in-Publication Data

America's words of freedom : speeches, documents, and writings that moved our country.
 p. cm.
 ISBN-13: 978-0-8249-5904-3 (alk. paper)
 ISBN-10: 0-8249-5904-3 (alk. paper)
 1. United States—History—Sources. 2. United States—Politics and government—Sources. 3.
Liberty—United States—History—Sources. 4. Democracy—United States—History—
Sources. 5. Speeches, addresses, etc., American. 6. United States—History—Pictorial works.
 E173.A765 2007
 973—dc22

 2006038472

Printed and bound in Italy

1 3 5 7 9 10 8 6 4 2

ACKNOWLEDGMENTS

CARSON, RACHEL. Excerpts from *Silent Spring* by Rachel Carson. Copyright 1962 by the author and renewed © 1990 by Roger Christie. Reprinted by permission of Houghton Mifflin Company. All rights reserved. HAND, LEARNED. From *The Spirit of Liberty* by Learned Hand, edited by I. Dilliard. Copyright © 1952, 1953, 1959, 1960 by Alfred A. Knopf, a division of Random House, Inc., and used with their permission. KING, MARTIN LUTHER JR. "I Have a Dream." Copyright © 1963 by Martin Luther King Jr., and renewed © 1991 by Coretta Scott King. Reprinted by arrangement with the Estate of Martin Luther King Jr., c/o Writers House as agent for the proprietor, New York, NY. WHITE, THEODORE H. "The American Idea" from *The New York Times,* July 6, 1986. Copyright © 1986 by Theodore H. White. Reprinted by permission.

Every effort has been made to establish ownership and use of each selection in this book. If contacted, thepublisher will be pleased to rectify any inadvertent errors or omissions in subsequent editions.

PHOTO CREDITS

Cover image: Creatas Images/Jupiter Images; p. 4 James Lemass/Index Stock/Jupiter Images; p. 7 SuperStock; p. 9 Purestock/SuperStock; p. 10 Steve Vidler/SuperStock; p. 13 Visions of America/SuperStock; p. 15 SuperStock; p. 16 George Hinke/Ideals; p. 19 Richard Cummins/SuperStock; p. 20 SuperStock; p. 23 Bruce & Jan Lichtenberger/SuperStock; p. 24 Claver Carroll/photolibrary/Jupiter Images; p. 27 SuperStock; p. 28 SuperStock; p. 31 Joe Sohm/Pan America/Jupiter Images; p. 33 age fotostock/SuperStock; p. 34 Kim Todd/Stock Connection/Jupiter Images; p. 37 Steve Vidler/SuperStock; p. 38 Leduc Stock/Workbook Stock/Jupiter Images; p. 41 SuperStock; p. 43 Alan Briere/SuperStock; p. 44 Corbis; p. 47 Jupiter Images; p. 49 David Forbert/SuperStock; p. 51 Bettmann/Corbis; p. 52 SuperStock; p. 55 Comstock/Jupiter Images; p. 56 SuperStock; p. 59 Yoshio Tomii/SuperStock; p. 61 Alan Briere/SuperStock; p. 63 SuperStock; p. 64 Pixtal/SuperStock; p. 67 age fotostock/SuperStock; p. 68 Orion Press/Jupiter Images; p. 71 SuperStock; p. 73 Dieter Klar/dpa/Corbis; p. 74 Greg Martin/SuperStock; p. 77 age fotostock/SuperStock; p. 79 Visions of America/SuperStock

I PLEDGE ALLEGIANCE TO THE FLAG

OF THE UNITED STATES OF AMERICA,

AND TO THE REPUBLIC FOR WHICH IT STANDS,

ONE NATION UNDER GOD, INDIVISIBLE,

WITH LIBERTY AND JUSTICE FOR ALL.

THE MAYFLOWER COMPACT

from William Bradford's *Of Plymouth Plantation, 1620–1647*

In the name of God, Amen. We, whose names are underwritten, the loyal subjects of our dread sovereign Lord King James, by the grace of God, of Great Britain, France, and Ireland, king, defender of the faith, etc., having undertaken, for the glory of God, and advancement of the Christian faith, and honour of our king and country, a voyage to plant the first colony in the Northern parts of Virginia, do by these presents, solemnly and mutually, in the presence of God, and one another, covenant and combine ourselves together into a civil body politick, for our better ordering and preservation, and further-ance of the ends aforesaid: and by virtue hereof do enact, constitute, and frame, such just and equal laws, ordinances, acts, constitutions, and officers, from time to time, as shall be thought most meet and convenient for the general good of the Colony, unto which we promise all due submission and obedience. In witness whereof we have hereunto subscribed our names at Cape Cod the 11 of November, in the reign of our sovereign lord King James, of England, France, and Ireland, the eighteenth, and of Scotland the fiftie fourth. Anº: Dom. 1620.

The Mayflower set sail across the Atlantic Ocean carrying 102 passengers with the intention of settling in territory controlled by the Virginia Company of London. When they found themselves instead landing beyond the borders controlled by their countrymen, the passengers agreed to sign a covenant guaranteeing government by law, by the consent of the governed. The Mayflower Compact, signed by forty-one of the male passengers in November of 1620, established self-rule for what would be known as Plymouth Colony. Many of the ship's passengers were members of an English separatist group seeking religious freedom; others came looking for new opportunities in America. In time, these settlers would be known by the name of Pilgrims, and their courage and perseverance would become a cherished part of our American heritage.

Speech *to the* Second Virginia Convention

Patrick Henry, 1775

I ask gentlemen, sir, what means this martial array, if its purpose be not to force us to submission? Can gentlemen assign any other possible motives for it? Has Great Britain any enemy, in this quarter of the world, to call for all this accumulation of navies and armies? No, sir, she has none. They are meant for us; they can be meant for no other. They are sent over to bind and rivet upon us those chains which the British ministry have been so long forging. . . . There is no longer any room for hope. If we wish to be free—if we mean to preserve inviolate those inestimable privileges for which we have been so long contending—if we mean not basely to abandon the noble struggle in which we have been so long engaged and which we have pledged ourselves never to abandon until the glorious object of our contest shall be obtained, we must fight! I repeat it, sir, we must fight! An appeal to arms and to the God of Hosts is all that is left us!

. . . There is no retreat but in submission and slavery! Our chains are forged! Their clanking may be heard on the plains of Boston! The war is inevitable—and let it come! I repeat it, sir, let it come!

It is vain, sir, to extenuate the matter. Gentlemen may cry peace, peace—but there is no peace. The war is actually begun! The next gale that sweeps from the North will bring to our ears the clash of resounding arms! Our brethren are already in the field! Why stand we here idle? What is it that gentlemen wish? What would they have? Is life so dear, or peace so sweet, as to be purchased at the price of chains and slavery? Forbid it, Almighty God! I know not what course others may take; but as for me, give me liberty, or give me death!

Patrick Henry was a Virginia lawyer and an outspoken proponent of American independence from Great Britain. First elected to the Virginia legislature in 1765, Henry went on to serve on the Virginia Committee of Correspondence and in the Continental Congress. The speech that made him famous—and that made the line "Give me liberty, or give me death!" a permanent part of American history—was delivered in March of 1775 at St. John's Church in Richmond, Virginia. Henry's aim was to convince the Virginia legislature to arm its militia to fight the British; the result was a surge in patriotism throughout the colonies.

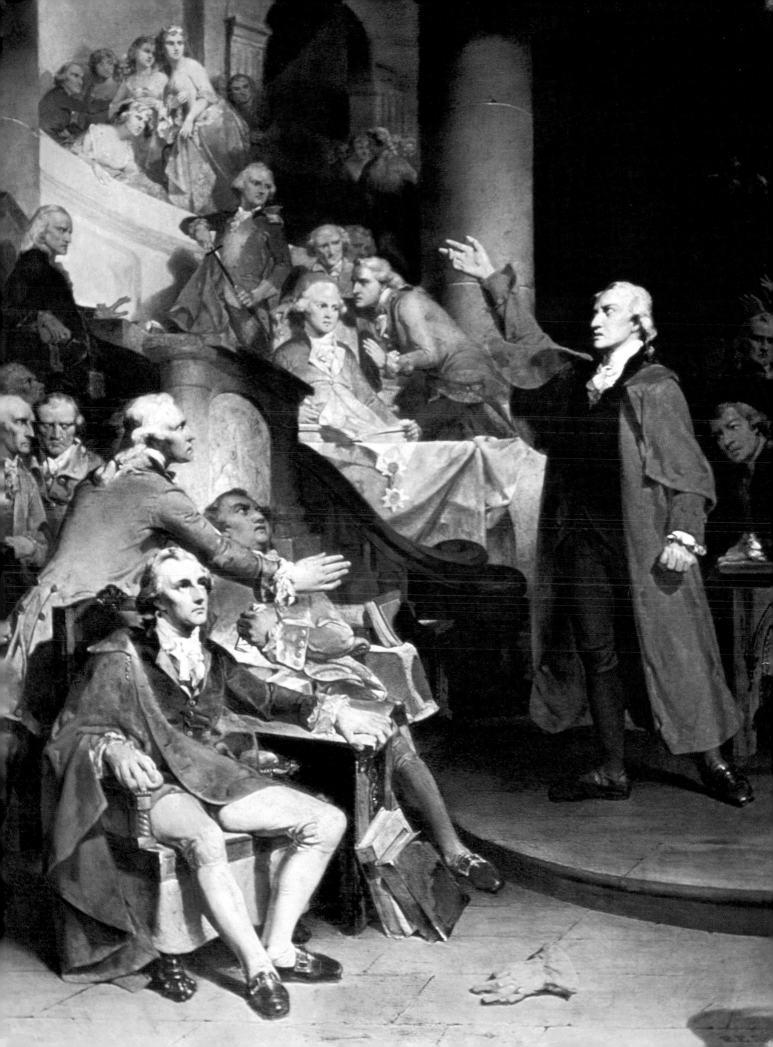

DECLARATION *of* INDEPENDENCE *of the* UNITED STATES OF AMERICA

1776

When in the Course of human events, it becomes necessary for one people to dissolve the political bands which have connected them with another, and to assume among the powers of the earth, the separate and equal station to which the Laws of Nature and of Nature's God entitle them, a decent respect to the opinions of mankind requires that they should declare the causes which impel them to the separation.

We hold these truths to be self-evident, that all men are created equal, that they are endowed by their Creator with certain unalienable Rights, that among these are Life, Liberty and the pursuit of Happiness.—That to secure these rights, Governments are instituted among Men, deriving their just powers from the consent of the governed,—That whenever any Form of Government becomes destructive of these ends, it is the Right of the People to alter or to abolish it, and to institute new Government, laying its foundation on such principles and organizing its powers in such form, as to them shall seem most likely to effect their Safety and Happiness. . . .

We, therefore, the Representatives of the united States of America, in General Congress, Assembled, appealing to the Supreme Judge of the world for the rectitude of our intentions, do, in the Name, and by Authority of the good People of these Colonies, solemnly publish and declare, That these United Colonies are, and of Right ought to be Free and Independent States; that they are Absolved from all Allegiance to the British Crown, and that all political connection between them and the State of Great Britain, is and ought to be totally dissolved; and that as Free and Independent States, they have full Power to levy War, conclude Peace, contract Alliances, establish Commerce, and to do all other Acts and Things which Independent States may of right do. And for the support of this Declaration, with a firm reliance on the protection of divine Providence, we mutually pledge to each other our Lives, our Fortunes and our sacred Honor.

The Declaration of Independence was drafted by a committee of five men, with Thomas Jefferson crafting the actual language. After changes from John Adams and Benjamin Franklin, the statement was presented to Congress on July 2, 1776. Additional revisions were made over the following two days, and Congress formally adopted the Declaration on the afternoon of July 4, 1776, a day we continue to celebrate as our nation's birthday.

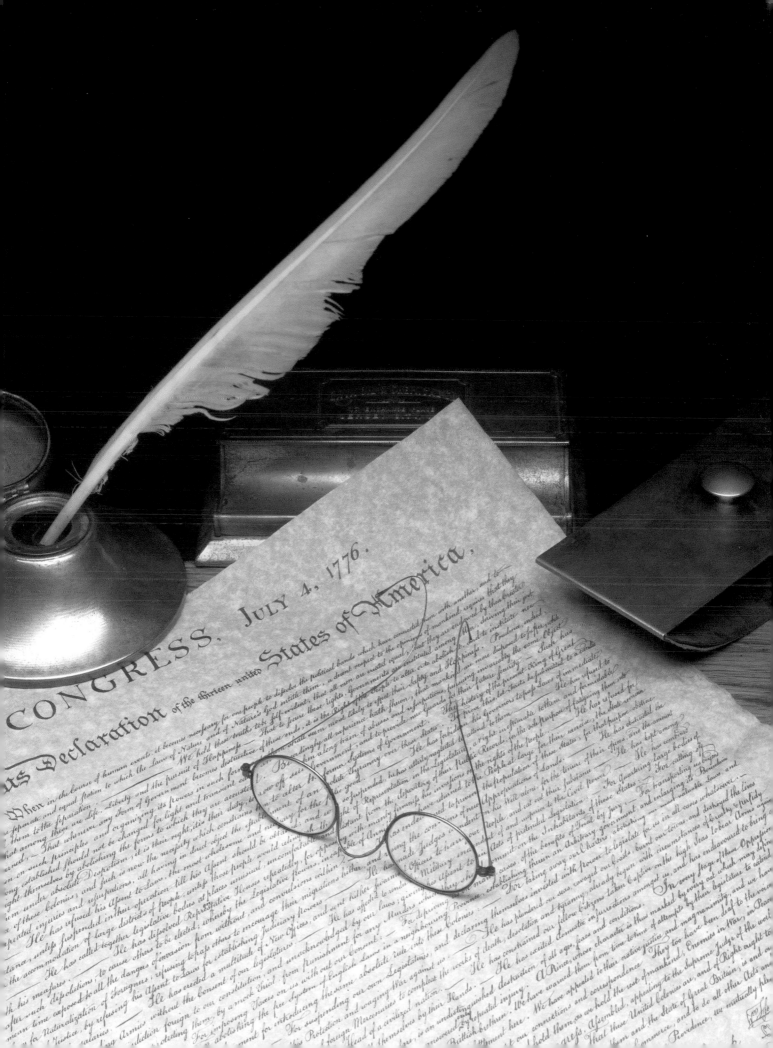

from COMMON SENSE

Thomas Paine, 1776

Where, say some, is the king of America? I'll tell you, friend, he reigns above, and doth not make havoc of mankind like the Royal Brute of Great Britain. Yet that may not appear to be defective even in earthly honors, let a day be solemnly set apart for proclaiming the charter; let it be brought forth placed upon the divine law, the Word of God; let a crown be placed thereon, by which the world may know, that so far as we approve of monarchy, that in America THE LAW IS KING. For as in absolute governments the king is law, so in free countries the law ought to be king, and there ought to be no other. But lest any ill use should afterwards arise, let the crown at the conclusion of the ceremony be demolished, and scattered among the people whose right it is. . . .

O ye that love mankind! Ye that dare oppose not only the tyranny but the tyrant, stand forth! Every spot of the old world is overrun with oppression. Freedom hath been hunted round the globe. Asia and Africa have long expelled her. Europe regards her like a stranger, and England hath given her warning to depart. O receive the fugitive, and prepare in time an asylum for mankind.

Thomas Paine was an outspoken leader in the cause of American independence. Born in 1737, Paine came to prominence in early 1776 with the publication of a pamphlet titled Common Sense. *Later that year he published the first of a series of sixteen pamphlets he called* The Crisis. *The pamphlets argued that fighting against taxation was not enough—Americans must demand complete and total independence. Paine's pamphlets sold close to five hundred thousand copies and helped stir the colonists to action. He will be forever remembered in American history as one of the boldest and most courageous champions of independence.*

from THE CONSTITUTION OF THE UNITED STATES OF AMERICA

1787

PREAMBLE

We the People of the United States, in Order to form a more perfect Union, establish Justice, insure domestic Tranquility, provide for the common defense, promote the general Welfare, and secure the Blessings of Liberty to ourselves and our Posterity, do ordain and establish this Constitution for the United States of America.

THE BILL OF RIGHTS, 1791

Amendment I. Congress shall make no law respecting an establishment of religion, or prohibiting the free exercise thereof; or abridging the freedom of speech, or of the press; or the right of the people peaceably to assemble, and to petition the Government for a redress of grievances.

Amendment II. A well regulated Militia, being necessary to the security of a free State, the right of the people to keep and bear Arms, shall not be infringed.

Amendment III. No Soldier shall, in time of peace be quartered in any house, without the consent of the Owner, nor in time of war, but in a manner to be prescribed by law.

Amendment IV. The right of the people to be secure in their persons, houses, papers, and effects, against unreasonable searches and seizures, shall not be violated, and no Warrants shall issue, but upon probable cause, supported by Oath or affir-mation, and particularly describing the place to be searched, and the persons or things to be seized.

Amendment V. No person shall be held to answer for a capital, or otherwise infamous crime, unless on a presentment or indictment of a Grand Jury, except in cases arising in the land or naval forces, or in the Militia, when in actual service in time of War or public danger; nor shall any person be subject for the same offense to be twice put in jeopardy of life or limb; nor shall be compelled in any criminal case to be a witness against himself, nor be deprived of life, liberty, or property, without due process of law; nor shall private property be taken for public use, without just compensation.

Amendment VI. In all criminal prosecutions, the accused shall enjoy the right of a speedy and public trial, by an impartial jury of the State and district wherein the crime shall have been committed,

which district shall have been previously ascertained by law, and to be informed of the nature and cause of the accusation; to be confronted with the witnesses against him; to have compulsory process for obtaining witnesses in his favor, and to have the Assistance of Counsel for his defence.

Amendment VII. In Suits at common law, where the value in controversy shall exceed twenty dollars, the right of trial by jury shall be preserved, and no fact tried by a jury, shall be otherwise re-examined in any Court of the United States, than according to the rules of the common law.

Amendment VII. Excessive bail shall not be required, nor excessive fines imposed, nor cruel and unusual punishments inflicted.

Amendment IX. The enumeration in the Constitution, of certain rights, shall not be construed to deny or disparage others retained by the people.

Amendment X. The powers not delegated to the United States by the Constitution, nor prohibited by it to the States, are reserved to the States respectively, or to the people.

The Constitution of the United States is comprised of the preamble, seven articles, and, at present, twenty-seven amendments. The first ten amendments are known as the Bill of Rights and were added within two years of the signing of the Constitution in 1787. The Constitution was not unanimously accepted when first presented for ratification by the states. But by 1788, the required nine states had ratified the document, and it became the basis of our system of federal government.

FAREWELL ADDRESS

George Washington, 1796

The unity of government which constitutes you one people is also now dear to you. It is justly so, for it is a main pillar in the edifice of your real independence, the support of your tranquility at home, your peace abroad; of your safety; of your prosperity; of that very liberty which you so highly prize. But as it is easy to foresee that, from different causes and from different quarters, much pains will be taken, many artifices employed to weaken in your minds the conviction of this truth; as this is the point in your political fortress against which the batteries of internal and external enemies will be most constantly and actively (though often covertly and insidiously) directed, it is of infinite moment that you should properly estimate the immense value of your national union to your collective and individual happiness; that you should cherish a cordial, habitual, and immovable attachment to it; accustoming yourselves to think and speak of it as of the palladium of your political safety and prosperity; watching for its preservation with jealous anxiety; discountenancing whatever may suggest even a suspicion that it can in any event be abandoned; and indignantly frowning upon the first dawning of every attempt to alienate any portion of our country from the rest, or to enfeeble the sacred ties which now link together the various parts.

For this you have every inducement of sympathy and interest. Citizens, by birth or choice, of a common country, that country has a right to concentrate your affections. The name of American, which belongs to you in your national capacity, must always exalt the just pride of patriotism more than any appellation derived from local discriminations. With slight shades of difference, you have the same religion, manners, habits, and political principles. You have in a common cause fought and triumphed together; the independence and liberty you possess are the work of joint counsels, and joint efforts of common dangers, sufferings, and successes. . . .

While, then, every part of our country thus feels an immediate and particular interest in union, all the parts combined cannot fail to find in the united mass of means and efforts greater strength, greater resource, proportionably greater security from external danger, a less frequent interruption of their peace by foreign nations; and, what is of inestimable value, they must derive from union an exemption from those broils and wars between themselves, which so frequently afflict neighboring countries not tied together by the same governments, which their own rival ships alone would be sufficient to produce, but which opposite foreign alliances, attachments, and intrigues would stimulate and embitter. Hence, likewise, they will avoid the necessity of those overgrown military establish-

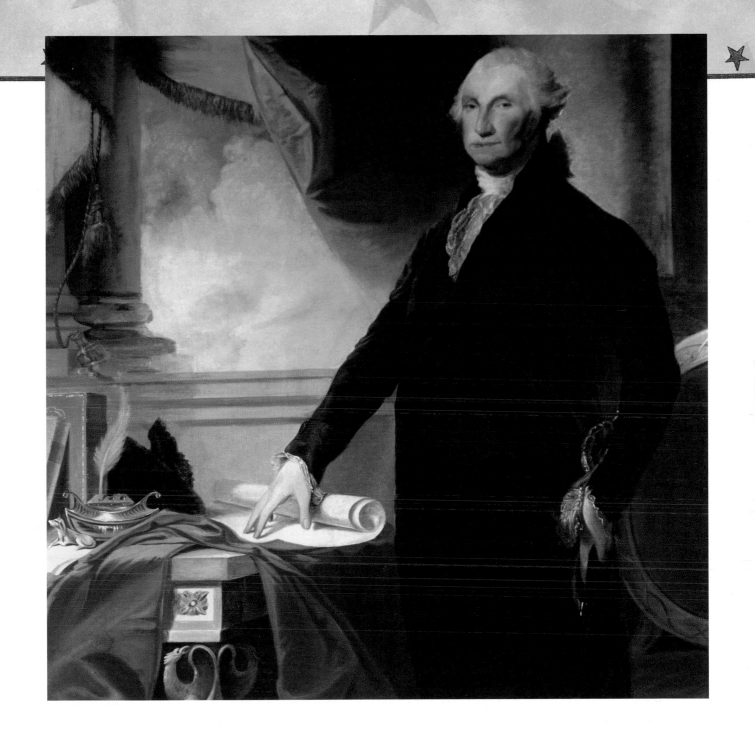

ments which, under any form of government, are inauspicious to liberty, and which are to be regarded as particularly hostile to republican liberty. In this sense it is that your union ought to be considered as a main prop of your liberty, and that the love of the one ought to endear to you the preservation of the other . . .

George Washington was chosen as our first president, due in large part to his leadership during the American Revolution and the Constitutional Convention. He served two terms before retiring from political life, despite the public's desire to see him run for a third term. In his farewell address, Washington warned of the dangers of sectionalism and advised neutrality in dealing with other countries. He retired to his estate, Mount Vernon, where he died two years later in 1799.

THE STAR-SPANGLED BANNER

Francis Scott Key, 1814

Oh say, can you see, by the dawn's early light,
What so proudly we hailed
 at the twilight's last gleaming,
Whose broad stripes and bright stars
 through the perilous fight,
O'er the ramparts we watched
 were so gallantly streaming?
And the rockets' red glare, the bombs bursting in air,
Gave proof thro' the night
 that our flag was still there.
Oh, say, does that star-spangled banner yet wave
O'er the land of the free and the home of the brave!

On the shore, dimly seen thro' the mists of the deep,
Where the foe's haughty host
 in dread silence reposes,
What is that which the breeze,
 o'er the towering steep,
As it fitfully blows,
 half conceals, half discloses?
Now it catches the gleam of the morning's first beam,
In full glory reflected,
 now shines in the stream.
'Tis the star-spangled banner; oh, long may it wave
O'er the land of the free, and the home of the brave!

And where is that band who so vauntingly swore
That the havoc of war
 and the battle's confusion
A home and a country
 should leave us no more?
Their blood has washed out
 their foul footsteps' pollution.
No refuge could save the hireling and slave
From the terror of flight
 or the gloom of the grave:
And the star-spangled banner in triumph doth wave
O'er the land of the free and the home of the brave!

Oh, thus be it ever, when freemen shall stand
Between their loved homes
 and the war's desolation;
Blest with victory and peace,
 may the heaven-rescued land
Praise the power that hath made
 and preserved us a nation!
Then conquer we must, when our cause it is just,
And this be our motto:
 "In God is our trust!"
And the star-spangled banner in triumph shall wave,
O'er the land of the free, and the home of the brave!

Although "The Star-Spangled Banner" was written by Francis Scott Key in September 1814, it would be more than one hundred years before it was officially designated our national anthem—first by the executive order of President Wilson in 1916 and later confirmed by an act of Congress in 1931.

A House Divided, Speech at Springfield

Abraham Lincoln, 1858

If we could first know where we are, and whither we are tending, we could better judge what to do, and how to do it. We are now far into the fifth year since a policy was initiated with the avowed object and confident promise of putting an end to slavery agitation. Under the operation of that policy, that agitation has not only not ceased, but has constantly augmented. In my opinion, it will not cease until a crisis shall have been reached and passed. "A house divided against itself cannot stand." I believe this government cannot endure permanently half slave and half free. I do not expect the Union to be dissolved; I do not expect the house to fall; but I do expect it will cease to be divided. It will become all one thing, or all the other. Either the opponents of slavery will arrest the further spread of it, and place it where the public mind shall rest in the belief that it is in the course of ultimate extinction, or its advocates will push it forward till it shall become alike lawful in all the States, old as well as new, North as well as South. . . .

Our cause, then, must be intrusted to, and conducted by, its own undoubted friends—those whose hands are free, whose hearts are in the work, who do care for the result. Two years ago the Republicans of the nation mustered over thirteen hundred thousand strong. We did this under the single impulse of resistance to a common danger, with every external circumstance against us. Of strange, discordant, and even hostile elements, we gathered from the four winds, and formed and fought the battle through, under the constant hot fire of a disciplined, proud and pampered enemy. Did we brave all then, to falter now,—now, when that same enemy is wavering, dissevered and belligerent? The result is not doubtful. We shall not fail; if we stand firm, we shall not fail. Wise counsels may accelerate, or mistakes delay it, but sooner or later, the victory is sure to come.

Abraham Lincoln delivered his "A house divided" speech while accepting his nomination to the Senate at the Republican Convention in 1858. His opponent in the Illinois race was Stephen A. Douglas, who had introduced the Kansas-Nebraska Act—a bill that let new western territories decide whether they wanted to allow slavery. A series of debates with Douglas followed during the campaign and garnered Lincoln national attention. Although he lost the election, the debates afforded Lincoln the opportunity to make known his position on slavery, which he viewed as unjust, and the need to protect the Union.

INDEPENDENCE DAY SPEECH

Frederick Douglass, 1852

Fellow citizens, pardon me, allow me to ask, why am I called upon to speak here today? What have I, or those I represent, to do with your national independence? . . . The blessings in which you, this day, rejoice are not enjoyed in common. The rich inheritance of justice, liberty, prosperity, and independence bequeathed by your fathers is shared by you, not by me. The sunlight that brought light and healing to you has brought stripes and death to me. This Fourth of July is yours, not mine. You may rejoice, I must mourn. To drag a man in fetters into the grand illuminated temple of liberty, and call upon him to join you in joyous anthems, were inhuman mockery and sacrilegious irony. . . .

Fellow citizens, above your national, tumultuous joy, I hear the mournful wail of millions whose chains, heavy and grievous yesterday, are, today, rendered more intolerable by the jubilee shouts that reach them. . . . I do not hesitate to declare with all my soul that the character and conduct of this nation never looked blacker to me than on this Fourth of July.

Whether we turn to the declarations of the past or to the professions of the present, the conduct of the nation seems equally hideous and revolting. America is false to the past, false to the present, and solemnly binds herself to be false to the future. Standing with God and the crushed and bleeding slave on this occasion, I will, in the name of humanity which is outraged, in the name of liberty which is fettered, in the name of the Constitution and the Bible which are disregarded and trampled upon, dare to call in question and to denounce, with all the emphasis I can command, everything that serves to perpetuate slavery—the great sin and shame of America! . . .

It is not light that is needed, but fire; it is not the gentle shower, but thunder. We need the storm, the whirlwind, and the earthquake. The feeling of the nation must be quickened; the conscience of the nation must be roused; the propriety of the nation must be startled; the hypocrisy of the nation must be exposed; and its crimes against God and man must be proclaimed and denounced.

The Independence Day oration was an established American tradition in the mid-1800s. Townspeople would gather each Fourth of July to hear speakers extol the virtues of their homeland. But on July 5, 1852, the citizens of Rochester, New York, heard a new take on the subject of independence. Freed slave Frederick Douglass, speaking that day to an audience ready for words of pride and praise, reminded the people of Rochester that their cherished independence meant little if it did not embrace Americans of all races. The words he spoke surprised many but gave pause to all who treasured their freedom and believed in the American ideal of independence.

THE BATTLE HYMN
of the REPUBLIC

Julia Ward Howe, 1862

Mine eyes have seen the glory of
 the coming of the Lord:
He is trampling out the vintage where
 the grapes of wrath are stored;
He hath loosed the fateful lightenings
 of His terrible swift sword:
His truth is marching on.

Glory! Glory! Hallelujah!
Glory! Glory! Hallelujah!
Glory! Glory! Hallelujah!
His truth is marching on.

I have seen Him in the watch-fires
 of a hundred circling camps;
They have builded Him an altar
 in the evening dews and damps:
I can read His righteous sentence
 by the dim and flaring lamps:
His day is marching on.

CHORUS
Glory! Glory! Hallelujah! . . .
His day is marching on.

I have read a fiery gospel writ
 in burnished rows of steel:
"As ye deal with my contemners,
 so with you my grace shall deal;
Let the Hero, born of woman,
 crush the serpent with his heel,
Since God is marching on."

CHORUS
Glory! Glory! Hallelujah! . . .
Since God is marching on.

He has sounded forth the trumpet
 that shall never call retreat:
He is sifting out the hearts of men
 before His judgment seat:
Oh, be swift, my soul, to answer Him!
 be jubilant my feet!
Our God is marching on!

CHORUS
Glory! Glory! Hallelujah! . . .
Our God is marching on.

In the beauty of the lilies
 Christ was born across the sea,
With a glory in His bosom that
 transfigures you and me;
As he died to make men holy,
 let us die to make men free,
While God is marching on.

CHORUS
Glory! Glory! Hallelujah! . . .
While God is marching on.

Julia Ward Howe wrote "The Battle Hymn of the Republic" in response to a challenge from a friend. While in Washington DC, Howe had visited a Union Army camp and joined the soldiers in singing the popular "John Brown's Body." Her friend suggested she write new lyrics for the marching song, and Howe did so the following morning, November 18, 1861. The song, which began as a Union Army song, has since been embraced as a patriotic anthem for all.

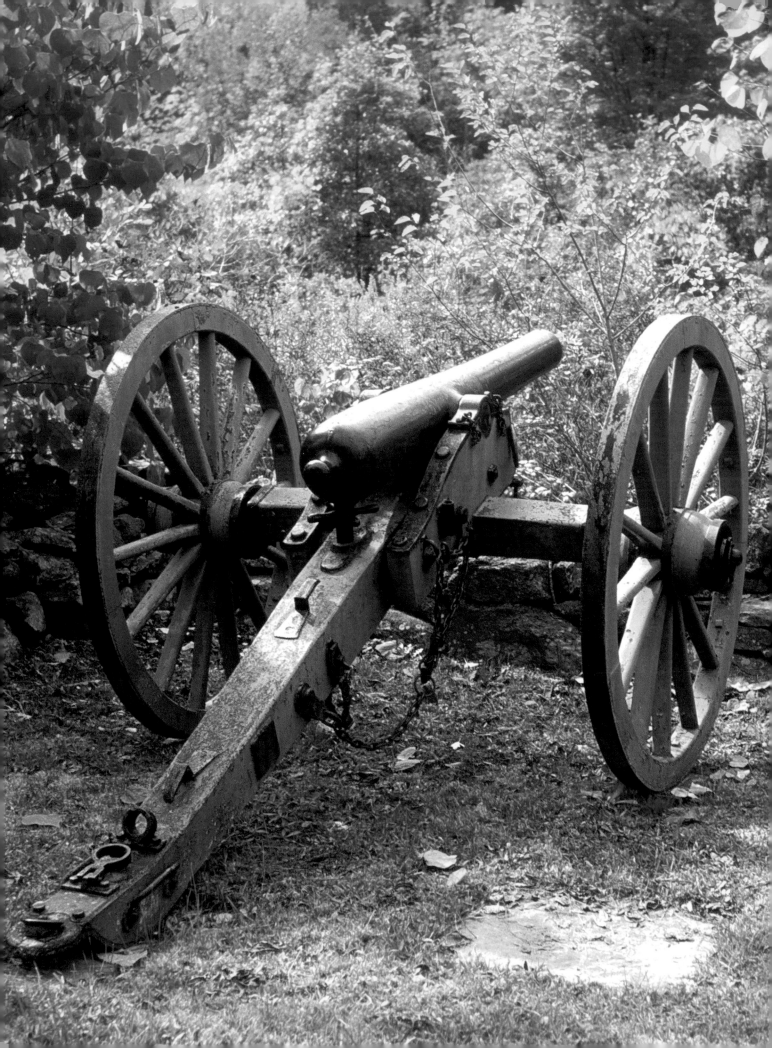

THE GETTYSBURG ADDRESS

Abraham Lincoln, 1863

Fourscore and seven years ago our fathers brought forth on this continent a new nation, conceived in liberty, and dedicated to the proposition that all men are created equal.

Now we are engaged in a great civil war, testing whether that nation, or any nation so conceived and so dedicated, can long endure. We are met on a great battle field of that war. We have come to dedicate a portion of that field as a final resting-place for those who here gave their lives that that nation might live. It is altogether fitting and proper that we should do this.

But, in a larger sense, we can not dedicate . . . we can not consecrate . . . we can not hallow . . . this ground. The brave men, living and dead, who struggled here, have consecrated it far above our poor power to add or detract. The world will little note nor long remember what we say here, but it can never forget what they did here. It is for us, the living, rather, to be dedicated here to the unfinished work which they who fought here have thus far so nobly advanced. It is rather for us to be here dedicated to the great task remaining before us . . . that from these honored dead we take increased devotion to that cause for which they gave the last full measure of devotion; that we here highly resolve[d] that these dead shall not have died in vain; that this nation, under God, shall have a new birth of freedom; and that government of the people, by the people, for the people, shall not perish from the earth.

The Gettysburg Address was delivered during the dedication of a military cemetery on the Civil War battlefield of Gettysburg, Pennsylvania. President Abraham Lincoln spoke for only a few moments, but his words—a moving tribute to those who gave their lives and a strong reminder of the need to keep the Union intact—continue to echo in the hearts and minds of the American people well over one hundred years later.

EMANCIPATION PROCLAMATION

Abraham Lincoln, 1863

Whereas, on the twenty-second day of September, AD 1862, a proclamation was issued by the President of the United States, containing, among other things, the following, to wit:

"That on the first day of January, AD 1863, all persons held as slaves within any State or designated part of a State, the people whereof shall then be in rebellion against the United States, shall be then, thenceforward, and forever free; and the Executive Government of the United States, including the military and naval authority thereof, will recognize and maintain the freedom of such persons, and will do no act or acts to repress such persons, or any of them, in any efforts they may make for their actual freedom." . . .

Now, therefore I, Abraham Lincoln, President of the United States, by virtue of the power in me vested as Commander-in-Chief, of the Army and Navy of the United States in time of actual armed rebellion against the authority and government of the United States, and as a fit and necessary war measure for suppressing said rebellion, do, on this first day of January, AD 1863, and in accordance with my purpose so to do publicly proclaimed for the full period of one hundred days, from the day first above mentioned, order and designate as the States and parts of States wherein the people thereof respectively, are this day in rebellion against the United States, the following, to wit: . . .

And by virtue of the power, and for the purpose aforesaid, I do order and declare that all persons held as slaves within said designated States, and parts of States, are, and henceforward shall be free; and that the Executive government of the United States, including the military and naval authorities thereof, will recognize and maintain the freedom of said persons. . . .

And upon this act, sincerely believed to be an act of justice, warranted by the Constitution, upon military necessity, I invoke the considerate judgment of mankind, and the gracious favor of Almighty God. . . .

On January 1, 1863, President Abraham Lincoln issued the Emancipation Proclamation, declaring free all slaves living in Confederate territories that were in rebellion against the federal government. The proclamation did not affect slaves living in loyal border states or those in Confederate territories that had already been conquered by Union forces, but it did change the character of the war and added moral authority to the Union cause. It was not until the Thirteenth Amendment was ratified in December 1865 that all slavery in the United States was abolished.

EMANCIPATION PROCLAMATION.

WHEREAS, On the 22nd day of September, A.D. 1862, a proclamation was issued by the President of the UNITED STATES, containing, among other things, the following, to wit:

"That on the 1st day of January, in the year of our Lord one thousand eight hundred and sixty three, all persons held as slaves within any State, or designated part of a State, the people whereof shall then be in rebellion against the UNITED STATES, shall be henceforth and forever FREE; and the Executive Government of the United States, including the Military and Naval authorities thereof, will recognize and maintain the freedom of such persons, and will do no act or acts to repress such persons, or any of them in any effort they may make for their actual freedom; that the Executive will, on the first day of January aforesaid, issue a proclamation designating the States and parts of States, if any, in which the people therein, respectively, shall then be in rebellion against the United States; and the fact that any State, or the people thereof, shall on that day be, in good faith, represented in the Congress of the United States by members chosen thereto, at elections wherein a majority of the qualified voters of such States shall have participated, shall, in the absence of strong countervailing testimony, be deemed conclusive evidence that such State and the people thereof, are not in rebellion against the United States."

Now, THEREFORE, I, ABRAHAM LINCOLN, PRESIDENT of the UNITED STATES, by virtue of the power in me vested as Commander-in-Chief of the Army and Navy, in a time of actual armed rebellion against the authority of the Government of the United States, as a fit and necessary war measure for suppressing said rebellion, do, on this FIRST DAY of JANUARY, in the year of our Lord ONE THOUSAND EIGHT HUNDRED and SIXTY-THREE, and in accordance with my purpose so to do, publicly proclaimed for the full period of one hundred days from the date of the first above mentioned order, designate as the States and parts of States therein, the people whereof respectively are this day in rebellion against the United States, the following, to-wit: ARKANSAS, TEXAS, LOUISIANA, except the Parishes of St. Bernard, Plaquemine, Jefferson, St. John, St. Charles, St. James, Ascension, Assumption, Terrebonne, La Fourche, St. Mary, St. Martin, and Orleans, including the city of New Orleans; MISSISSIPPI, ALABAMA, FLORIDA, GEORGIA, SOUTH CAROLINA, NORTH CAROLINA, and VIRGINIA, except the forty-eight counties designated as West Virginia, and also the counties of Berkley, Accomac, Northampton, Elizabeth City, York, Princess Anne, and Norfolk, including the cities of Norfolk and Portsmouth; which excepted parts are for the present left precisely as if this proclamation were not issued. And by virtue of the power and for the purpose aforesaid, I DO ORDER and DECLARE, that ALL PERSONS HELD AS SLAVES within designated States, and parts of States, are, and henceforward SHALL BE FREE, and that the Executive Government of the United States, including the military and naval authorities thereof, will recognize and maintain the freedom of the said persons; and I hereby enjoin upon the people so declared to be free to abstain from all violence, unless in necessary self-defence, and I recommend to them that, in all cases where allowed, they LABOR FAITHFULLY for REASONABLE WAGES; and I further declare and make known that such persons of suitable condition will be received into the armed service of the UNITED STATES, to GARRISON FORTS, POSITIONS, STATIONS, and other places, and to man VESSELS, of all sorts in said service.

And upon this, sincerely believed to be an AN ACT OF JUSTICE, WARRANTED by the CONSTITUTION, upon military necessity, I invoke the CONSIDERATE judgment of MANKIND and the GRACIOUS FAVOR of ALMIGHTY GOD.

In witness whereof, I have hereunto set my hand and caused the seal of the United States, to be affixed.

Done at the CITY OF WASHINGTON this FIRST DAY of JANUARY, in the year of our Lord ONE THOUSAND EIGHT HUNDRED and SIXTY-THREE, and of the INDEPENDENCE of the UNITED STATES of AMERICA the EIGHTY-SEVENTH.

(Signed)

ABRAHAM LINCOLN.

By the President:
WM. H. SEWARD, Secretary of State.

THIS PROCLAMATION is an incalculable element of strength to the Union cause. It makes an alliance between the Rebels and Foreign States as impossible as it is for millions of Bondsmen to love Slavery better than Freedom. They loving our Government in proportion as it becomes a foe land of promise and shelter from oppression, thus saving thousands of precious lives and millions of treasure from being lost to foreign wars. It perfects the purposes of the DECLARATION OF INDEPENDENCE and impels on constitutional rights, those whom it would affect, having forfeited those rights by proving false to their country, to humanity and religion. No real support to the Union cause will be lost by this Proclamation, while time-serving traitors, who always covertly opposed the war, will be exposed. It will be a powerful incentive to the slaves to fight for the Union instead of his rebel master, and when it becomes enrolled and Freedom reigns throughout the land, the colored man will leave the Northern regions, whither he had fled from slavery, and join his kindred beneath those sunny skies where nature invites him. Labor will be rewarded, justice fulfilled, and the Old Ship of State will again sail majestic o'er the unrippled waters of Liberty and Peace. Confusion and shame rest upon those who fight against a free Government, and songs of thankfulness and love glorify its defenders.

RUFUS BLANCHARD, Publisher, 52 La Salle St. Chicago, Ill.

THE SURRENDER
of GENERAL ROBERT E. LEE

Ulysses S. Grant, 1865

What General Lee's feelings were I do not know. As he was a man of much dignity, with an impassible face, it was impossible to say whether he felt inwardly glad that the end had finally come, or felt sad over the result, and was too manly to show it. Whatever his feelings, they were entirely concealed from my observation; but my own feelings, which had been quite jubilant on the receipt of his letter, were sad and depressed. I felt like anything rather than rejoicing at the downfall of a foe who had fought so long and valiantly.

General Lee was dressed in a full uniform which was entirely new, and was wearing a sword of considerable value, very likely the sword which had been presented by the State of Virginia; at all events, it was an entirely different sword from the one that would ordinarily be worn in the field. In my rough traveling suit, the uniform of a private with the straps of a lieutenant-general, I must have contrasted very strangely with a man so handsomely dressed, six feet high and of faultless form. But this was not a matter that I thought of until afterwards.

We soon fell into a conversation about old army times. . . . Our conversation grew so pleasant that I almost forgot the object of our meeting. After the conversation had run on in this style for some time, General Lee called my attention to the object of our meeting, and said he had asked for this interview for the purpose of getting from me the terms I had proposed to give his army. I said that I meant merely that his army should lay down its arms, not to take them up again during the continuance of the war unless duly and properly exchanged. He said that he had so understood my letter. . . .

When news of the surrender first reached our lines our men commenced firing a salute of a hundred guns in honor of the victory. I at once sent word, however, to have it stopped. The Confederates were now our prisoners, and we did not want to exult over their downfall.

It was at Appomattox Court House in central Virginia that General Robert E. Lee, commander of the Army of Northern Virginia, surrendered to Union General Ulysses S. Grant on April 9, 1865. Lee's surrender followed the defeat of the Confederates at Five Forks on April 1, 1865, and the subsequent westward retreat of the Confederate Army. Cut off from supplies and surrounded by Union troops, Lee had no choice but to surrender, leading to the end of the Civil War, or the War Between the States, as it is also known.

from THE LEWIS and CLARK EXPEDITION

Meriwether Lewis, November 7, 1805

Here the mountainous country again approaches the river on the left, and a higher mountain is distinguished towards the southwest. At a distance of twenty miles from our camp we halted at a village of Wahkiacums . . . situated at the foot of the high hills on the right, behind two small marshy islands. We merely stopped to purchase some food and two beaver skins, and then proceeded. Opposite to these islands the hills on the left retire, and the river widens into a kind of bay crowded with low islands, subject to be overflowed occasionally by the tide. We had not gone far from this village when the fog cleared off, and we enjoyed the delightful prospect of the ocean; that ocean, the object of all our labours, the reward of all our anxieties. This cheering view exhilarated the spirits of all the party, who were still more delighted on hearing the distant roar of the breakers. We went on with great cheerfulness under the high mountainous country which continued along the right bank; the shore was however so bold and rocky, that we could not, until after going fourteen miles from the last village, find any spot fit for an encampment. At that distance, having made during the day thirty-four miles, we spread our mats on the ground, and passed the night. . . .

In 1803 President Thomas Jefferson commissioned Meriwether Lewis and William Clark to explore the land from the Mississippi River to the Pacific Ocean. Their party left St. Louis on May 14, 1804, and arrived on the shores of the Pacific in mid-November 1805. In the words of President Theodore Roosevelt, Lewis and Clark "opened the door into the heart of the far West" and began the great westward expansion of America.

THE ORATION

Chief Seattle, 1854

There was a time when our people covered the land as the waves of a wind-ruffled sea cover its shell paved floor, but that time long since passed away with the greatness of tribes that are now but a mournful memory. I will not dwell on, nor mourn over, our untimely decay, nor reproach my paleface brothers with hastening it as we too may have been somewhat to blame. . . .

A few more moons. A few more winters—and not one of the descendants of the mighty hosts that once moved over this broad land or lived in happy homes, protected by the Great Spirit, will remain to mourn over the graves of a people—once more powerful and hopeful than yours. But why should I mourn at the untimely fate of my people? Tribe follows tribe, and nation follows nation, like the waves of the sea. It is the order of nature, and regret is useless. Your time of decay may be distant, but it will surely come, for even the White Man whose God walked and talked with him as friend with friend, cannot be exempt from the common destiny. We may be brothers after all. We will see.

We will ponder your proposition and when we decide we will let you know. But should we accept it, I here and now make this condition that we will not be denied the privilege without molestation of visiting at any time the tombs of our ancestors, friends and children. Every part of this soil is sacred in the estimation of my people. Every hillside, every valley, every plain and grove, has been hallowed by some sad or happy event in days long vanished. Even the rocks, which seem to be dumb and dead as they swelter in the sun along the silent shore, thrill with memories of stirring events connected with the lives of my people, and the very dust upon which you now stand responds more lovingly to their footsteps than to yours, because it is rich with the blood of our ancestors and our bare feet are conscious of the sympathetic touch. Our departed braves, fond mothers, glad, happy-hearted maidens, and even the little children who lived here and rejoiced here for brief season, will love these somber solitudes and at eventide they greet shadowy returning spirits. And when the last Red Man shall have perished, and the memory of my tribe shall have become a myth among the White Men, these shores will swarm with the invisible dead of my tribe, and when your children's children think themselves alone in the field, the store, the shop, upon the highway, or in the silence of the pathless woods, they will not be alone. In all the earth there is no place dedicated to solitude. At night when the streets of your cities and villages are silent and you think them deserted, they will throng with the returning hosts that once filled them and still love this beautiful land. The White Man will never be alone.

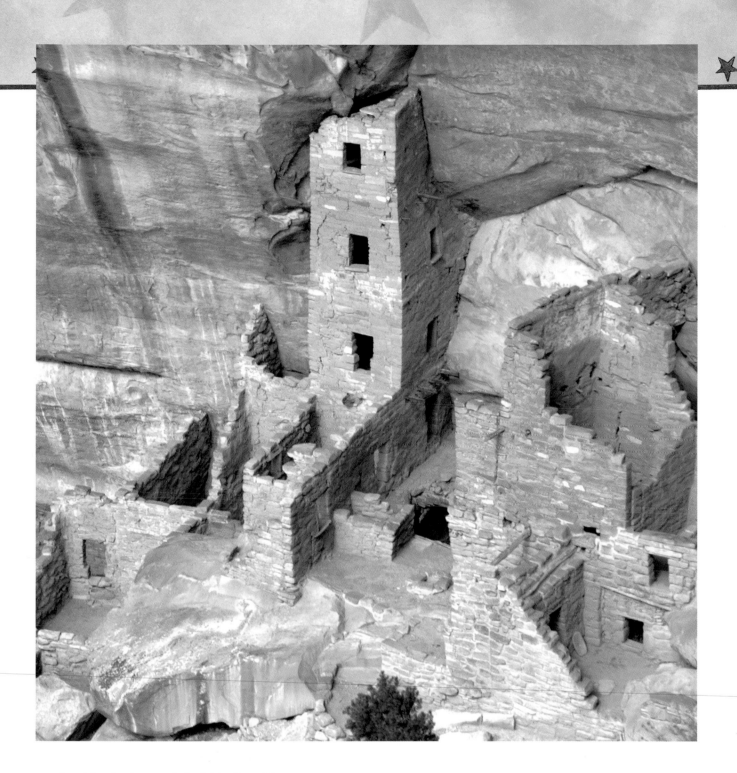

Let him be just and deal kindly with my people, for the dead are not powerless. Dead, did I say? There is no death, only a change of worlds.

Chief Seattle, a leader of six Native American tribes in the Pacific Northwest, delivered his "Oration" in response to the American government's offer to buy his people's land and move them to a reservation. His words revealed his view of the world and the way of life of his people. He movingly reminded us that no matter how our lives and our land change, the past is always with us.

THE HOMESTEAD ACT

1862

An Act to secure Homesteads to actual Settlers on the Public Domain.

Be it enacted by the Senate and House of Representatives of the United States of America in Congress assembled, That any person who is the head of a family, or who has arrived at the age of twenty-one years, and is a citizen of the United States, or who shall have filed his declaration of intention to become such, as required by the naturalization laws of the United States, and who has never borne arms against the United States Government or given aid and comfort to its enemies, shall, from and after the first January, eighteen hundred and. sixty-three, be entitled to enter one quarter section or a less quantity of unappropriated public lands, upon which said person may have filed a preemption claim, or which may, at the time the application is made, be subject to preemption at one dollar and twenty-five cents, or less, per acre; or eighty acres or less of such unappropriated lands, at two dollars and fifty cents per acre, to be located in a body, in conformity to the legal subdivisions of the public lands, and after the same shall have been surveyed: Provided, That any person owning and residing on land may, under the provisions of this act, enter other land lying contiguous to his or her said land, which shall not, with the land so already owned and occupied, exceed in the aggregate one hundred and sixty acres.

Approximately 270 million acres, or nearly 10 percent of the area of the United States, was settled under the Homestead Act, which President Abraham Lincoln signed into law in 1862. The impact of the legislation was immense, accelerating the settlement of the western territory and making public land available to private citizens for a relatively minimal sum.

AMERICA *the* BEAUTIFUL

Katharine Lee Bates, 1913

O beautiful for spacious skies,
For amber waves of grain,
For purple mountain majesties
Above the fruited plain!
America! America!
God shed His grace on thee,
And crown thy good
 with brotherhood
From sea to shining sea!

O beautiful for pilgrim feet
Whose stern, impassion'd stress
A thoroughfare for freedom beat
Across the wilderness!
America! America!
God mend thine ev'ry flaw,
Confirm thy soul
 in self-control,
Thy liberty in law!

O beautiful for heroes proved
In liberating strife,
Who more than self
 their country loved,
And mercy more than life!
America! America!
May God thy gold refine,
Till all success be nobleness,
And ev'ry gain divine!

O beautiful for patriot dream
That sees beyond the years
Thine alabaster cities gleam,
Undimm'd by human tears!
America! America!
God shed His grace on thee
And crown thy good
 with brotherhood
From sea to shining sea!

A professor of literature at Wellesley College, Katharine Lee Bates penned the lyrics to "America the Beautiful" following an inspiring visit to Pikes Peak in 1893. She later revised the lyrics in 1904 and again in 1913. Following its first publication in The Congregationalist *magazine, the words were sung to a number of different tunes. Eventually the lyrics became associated with the melody of "Materna," composed by Samuel A. Ward in 1882, more than a decade before the poem was written. That is the tune to which we sing the song today.*

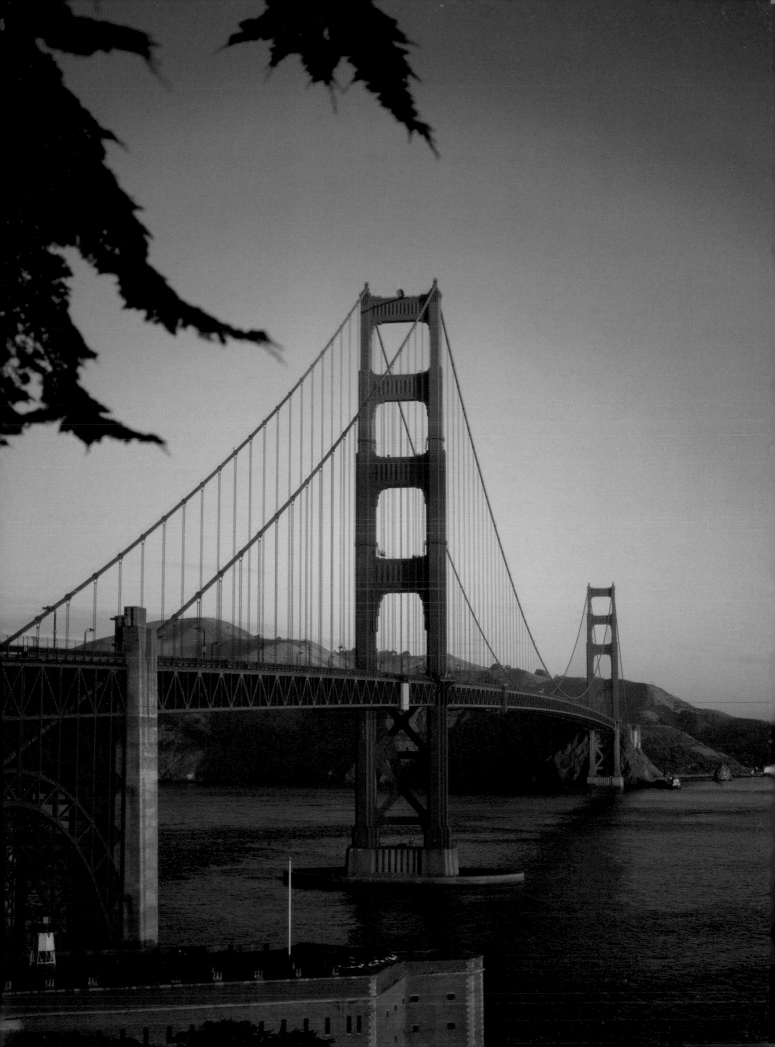

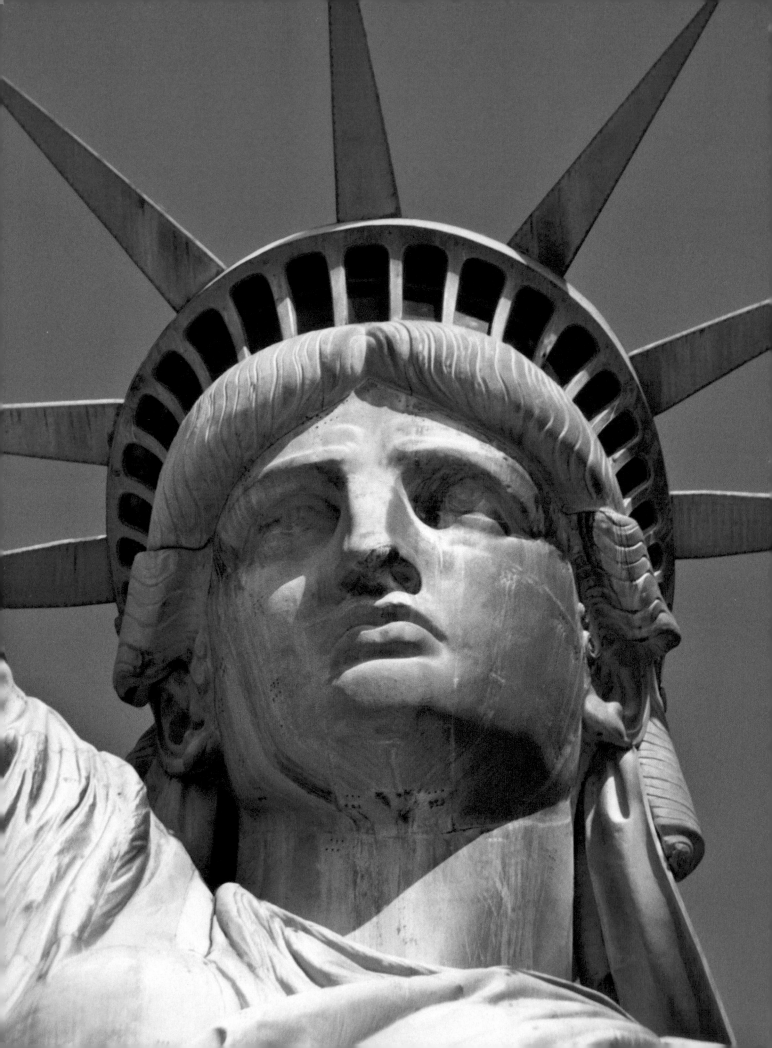

THE NEW COLOSSUS

Emma Lazarus, 1883

Not like the brazen giant of Greek fame,
With conquering limbs astride from land to land;
Here at our sea-washed, sunset gates shall stand
A mighty woman with a torch, whose flame
Is the imprisoned lightning, and her name
Mother of Exiles. From her beacon-hand
Glows world-wide welcome; her mild eyes command
The air-bridged harbor that twin cities frame.

"Keep, ancient lands, your storied pomp!" cries she
With silent lips. "Give me your tired, your poor,
Your huddled masses yearning to breathe free,
The wretched refuse of your teeming shore.
Send these, the homeless, tempest-tost to me,
I lift my lamp beside the golden door!"

The Statue of Liberty was dedicated by President Grover Cleveland on October 28, 1886, at a ceremony on Bedloe's Island off the coast of New York City. The statue, a gift from the French in honor of one hundred years of American independence, weighed 250 tons and stood 151 feet tall. The poem we so closely associate with the statue, "The New Colossus," did not play a role in the ceremony. Emma Lazarus wrote the poem in 1883, but it was not until 1903 that it was placced on a plaque inside the entrance of the statue. Some Americans were reluctant to embrace the sentiment of "huddled masses." In 1945, when Americans could no longer deny the contributions that recent immigrants had made to their society nor the pride they felt at our country being the refuge of displaced peoples from across the world, "The New Colossus" took its rightful place just outside the entrance of the Statue of Liberty.

ADDRESS *to the* OHIO WOMEN'S RIGHTS CONVENTION

Sojourner Truth, 1851

Well, children, where there is so much racket there must be something out of kilter. I think that twixt the Negroes of the South and the women at the North, all talking about rights, the white men will be in a fix pretty soon. But what's all this here talking about?

That man over there says that women need to be helped into carriages, and lifted over ditches, and to have the best place everywhere. Nobody ever helps me into carriages, or over mud puddles, or gives me any best place! And ain't I a woman? Look at me! Look at my arm! I have ploughed and planted, and gathered into barns, and no man could head me! And ain't I a woman? I could work as much and eat as much as a man—when I could get it—and bear the lash as well! And ain't I a woman? I have borne thirteen children, and seen them most all sold off to slavery, and when I cried out with my mother's grief, none but Jesus heard me! And ain't I a woman?

Then they talk about this thing in the head; what's this they call it? . . . That's it, honey. What's that got to do with women's rights or Negro's rights? If my cup won't hold but a pint, and yours holds a quart, wouldn't you be mean not to let me have my little half-measure full?

Then that little man in black there, he says that women can't have as much rights as men, 'cause Christ wasn't a woman! Where did your Christ come from? Where did your Christ come from? From God and a woman! Man had nothing to do with Him.

If the first woman God ever made was strong enough to turn the world upside down all alone, these women together ought to be able to turn it back, and get it right side up again! And now they is asking to do it, the men better let them.

Obliged to you for hearing me, and now old Sojourner ain't got nothing more to say.

Sojourner Truth was born into slavery in Ulster County, New York, around 1797. Given the name Isabella, she lived out her childhood and early adulthood as a slave before gaining her freedom sometime in the 1830s. As a free woman, Isabella traveled to New York City, where she worked as a paid domestic servant. In 1843 Isabella renamed herself Sojourner Truth and set out on the road to preach about the love of God. A compelling speaker, Sojourner began to draw crowds and soon added abolition and women's rights to her mission. Many at first objected to her presence, fearing that the cause of women's rights would become inseparable in the public mind from that of abolition, but all who heard her speak agreed that hers was a voice that must be heard.

IS IT *a* CRIME *to* VOTE?

Susan B. Anthony, 1872

Friends and Fellow-citizens: I stand before you to-night, under indictment for the alleged crime of having voted at the last Presidential election, without having a lawful right to vote. It shall be my work this evening to prove to you that in thus voting, I not only committed no crime, but, instead, simply exercised my citizen's right, guaranteed to me and all United States citizens by the National Constitution, beyond the power of any State to deny.

Our democratic-republican government is based on the idea of the natural right of every individual member thereof to a voice and a vote in making and executing the laws. We assert the province of government to be to secure the people in the enjoyment of their unalienable rights. We throw to the winds the old dogma that governments can give rights. Before governments were organized, no one denies that each individual possessed the right to protect his own life, liberty and property. . . .

It was we, the people, not we, the white male citizens, nor yet we, the male citizens; but we, the whole people, who formed this Union. And we formed it, not to give the blessings or liberty, but to secure them; not to the half of ourselves and the half of our posterity, but to the whole people—women as well as men. And it is downright mockery to talk to women of their enjoyment of the blessings of liberty while they are denied the use of the only means of securing them provided by this democratic-republican government-the ballot. . . .

A passionate supporter of women's rights, Susan B. Anthony was arrested along with fifteen other women for registering and then voting in the 1872 presidential election. The speech above was Anthony's response to the arrest prior to her trial. Sadly, she did not live to see the culmination of her many years of hard work. At the time of Anthony's death in 1906, only four states had granted women the right to vote. The Nineteenth Amendment, granting all American women the right to vote, was adopted in 1920.

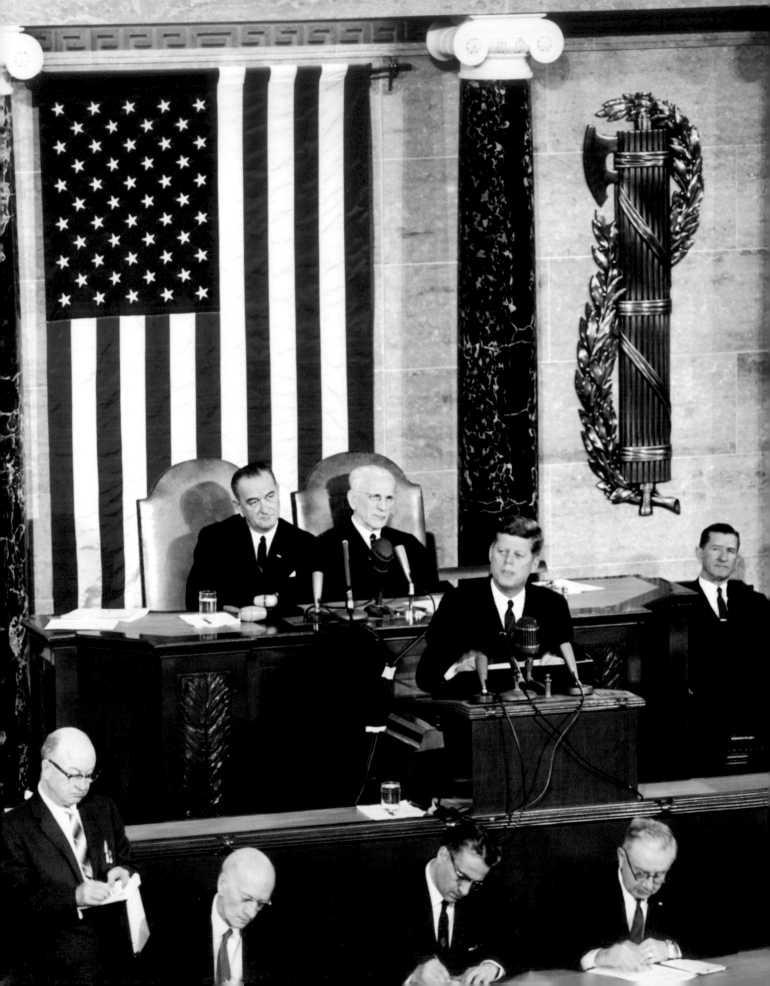
IN GOD WE TRUST ★ ★ ★

Inaugural Address

John F. Kennedy, 1961

Man holds in his mortal hands the power to abolish all forms of human poverty and all forms of human life. And yet the same revolutionary beliefs for which our forebears fought are still at issue around the globe—the belief that the rights of man come not from the generosity of the state but from the hand of God.

We dare not forget today that we are the heirs of that first revolution. Let the word go forth from this time and place, to friend and foe alike, that the torch has been passed to a new generation of Americans—born in this century, tempered by war, disciplined by a hard and bitter peace, proud of our ancient heritage—and unwilling to witness or permit the slow undoing of those human rights to which this nation has always been committed, and to which we are committed today at home and around the world.

Let every nation know, whether it wishes us well or ill, that we shall pay any price, bear any burden, meet any hardship, support any friend, oppose any foe to assure the survival and the success of liberty. . . .

In the long history of the world, only a few generations have been granted the role of defending freedom in its hour of maximum danger. I do not shrink from this responsibility—I welcome it. I do not believe that any of us would exchange places with any other people or any other generation. The energy, the faith, the devotion which we bring to this endeavor will light our country and all who serve it—and the glow from that fire can truly light the world.

And so, my fellow Americans: ask not what your country can do for you—ask what you can do for your country.

My fellow citizens of the world: ask not what America will do for you, but what together we can do for the freedom of man.

Finally, whether you are citizens of America or citizens of the world, ask of us here the same high standards of strength and sacrifice which we ask of you. With a good conscience our only sure reward, with history the final judge of our deeds, let us go forth to lead the land we love, asking His blessing and His help, but knowing that here on earth God's work must truly be our own.

John F. Kennedy, the youngest man and first Catholic ever elected president, won the White House with his pledge to lead America boldly into the future. In his inaugural address, Kennedy acknowledged the dangers of the cold war and the nuclear age and issued a call to service for thousands of volunteers. He signed an executive order establishing the Peace Corps just weeks later on March 1. Kennedy's term was cut short by an assassin's bullet on November 22, 1963, in Dallas, Texas.

BROWN V. BOARD *of* EDUCATION

1954

Today, education is perhaps the most important function of state and local governments. Compulsory school attendance laws and the great expenditures for education both demonstrate our recognition of the importance of education to our democratic society. It is required in the performance of our most basic public responsibilities, even service in the armed forces. It is the very foundation of good citizenship. Today it is a principal instrument in awakening the child to cultural values, in preparing him for later professional training, and in helping him to adjust normally to his environment. In these days, it is doubtful that any child may reasonably be expected to succeed in life if he is denied the opportunity of an education. Such an opportunity, where the state has undertaken to provide it, is a right which must be made available to all on equal terms.

We come then to the question presented: Does segregation of children in public schools solely on the basis of race, even though the physical facilities and other "tangible" factors may be equal, deprive the children of the minority group of equal educational opportunities? We believe that it does.

. . . To separate [children] from others of similar age and qualifications solely because of their race generates a feeling of inferiority as to their status in the community that may affect their hearts and minds in a way unlikely ever to be undone.

The effect of this separation on their educational opportunities was well stated by a finding in the Kansas case by a court which nevertheless felt compelled to rule against the Negro plaintiffs:

Segregation of white and colored children in public schools has a detrimental effect upon the colored children. The impact is greater when it has the sanction of the law, for the policy of separating the races is usually interpreted as denoting the inferiority of the negro group. A sense of inferiority affects the motivation of a child to learn. Segregation with the sanction of law, therefore, has a tendency to [retard] the educational and mental development of negro children and to deprive them of some of the benefits they would receive in a racial[ly] integrated school system. . . .

We conclude that, in the field of public education, the doctrine of "separate but equal" has no place. Separate educational facilities are inherently unequal. Therefore, we hold that the plaintiffs and others similarly situated for whom the actions have been brought are, by reason of the segregation complained of, deprived of the equal protection of the laws guaranteed by the Fourteenth Amendment. This disposition makes unnecessary any discussion whether such segregation also violates the Due Process Clause of the Fourteenth Amendment.

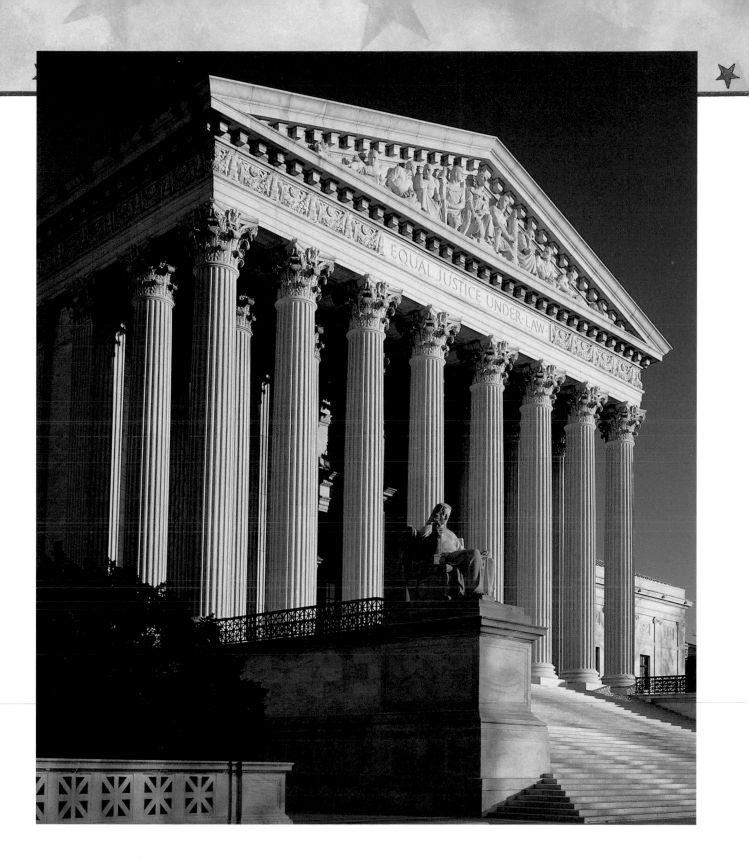

In this landmark 1954 decision, the Supreme Court ruled that segregation in public schools was a violation of the Fourteenth Amendment of the Constitution. It brought to an end the policy of "separate but equal" and became a catalyst for the civil rights movement of the 1950s and 1960s.

I Have a Dream

Martin Luther King Jr., 1963

I say to you today, my friends, that in spite of the difficulties and frustrations of the moment I still have a dream. It is a dream deeply rooted in the American dream.

I have a dream that one day this nation will rise up and live out the true meaning of its creed: "We hold these truths to be self-evident; that all men are created equal."

I have a dream that one day on the red hills of Georgia the sons of former slaves and the sons of former slave owners will be able to sit down together at the table of brotherhood.

I have a dream that one day even the state of Mississippi, a desert state sweltering with the heat of injustice and oppression, will be transformed into an oasis of freedom and justice.

I have a dream that my four little children will one day live in a nation where they will not be judged by the color of their skin but by the content of their character.

I have a dream today.

I have a dream that one day the state of Alabama, whose governor's lips are presently dripping with the words of interposition and nullification, will be transformed into a situation where little black boys and black girls will be able to join hands with little white boys and girls and walk together as sisters and brothers.

I have a dream today.

I have a dream that one day every valley shall be exalted, every hill and mountain shall be made low, the rough places will be made plain, and the crooked places will be made straight, and the glory of the Lord shall be revealed, and all flesh shall see it together. . . .

This will be the day when all of God's children will be able to sing with new meaning, "My country 'tis of thee, sweet land of liberty, of thee I sing. Land where my father died, land of the Pilgrims' pride, from every mountainside, let freedom ring."

And if America is to be a great nation, this must become true. So let freedom ring from the prodigious hilltops of New Hampshire. Let freedom ring from the mighty mountains of New York. Let freedom ring from the heightening Alleghenies of Pennsylvania! . . .

Let freedom ring from every hill and molehill of Mississippi. From every mountainside, let freedom ring.

When we let freedom ring, when we let it ring from every village and every hamlet, from every state and every city, we will be able to speed up that day when all of God's children, black men and white men, Jews and Gentiles, Protestants and Catholics, will be able to join hands and sing in the words of the old Negro spiritual, "Free at last! Free at last! Thank God Almighty, we are free at last!"

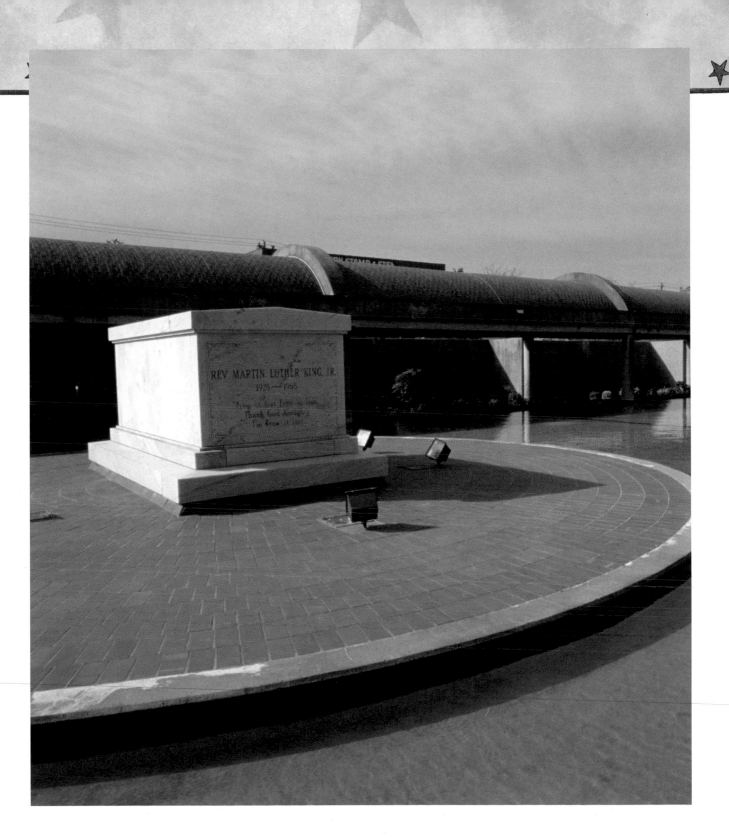

The 1963 "March on Washington" brought 250,000 people to the nation's capital to demand passage of meaningful civil rights legislation. Martin Luther King Jr., a clergyman and civil rights leader who advocated a philosophy of nonviolent resistance, addressed the crowd from the steps of the Lincoln Memorial. King was assassinated in Memphis, Tennessee, on April 4, 1968, but the eloquence of his "I have a dream" speech still resonates with people everywhere.

CIVIL RIGHTS ACT *of* 1964

An Act

To enforce the constitutional right to vote, to confer jurisdiction upon the district courts of the United States to provide injunctive relief against discrimination in public accommodations, to authorize the Attorney General to institute suits to protect constitutional rights in public facilities and public education, to extend the Commission on Civil Rights, to prevent discrimination in federally assisted programs, to establish a Commission on Equal Employment Opportunity, and for other purposes.

Be it enacted by the Senate and House of Representatives of the United States of America in Congress assembled, That this Act may be cited as the "Civil Rights Act of 1964".

The Civil Rights Act, signed into law by President Lyndon B. Johnson in 1964, was first urged by President John F. Kennedy as part of his effort to bring equality to all Americans. The act was a sweeping and comprehensive piece of legislation. It outlawed discrimination in businesses such as restaurants, hotels, and theaters; forbade discrimination in employment practices; and ended segregation in public places such as schools, libraries, and swimming pools. The Voting Rights Act, which ensured equal voting rights for all citizens, followed in 1965, and the Civil Rights Act of 1968 addressed discriminatory practices in housing and real estate.

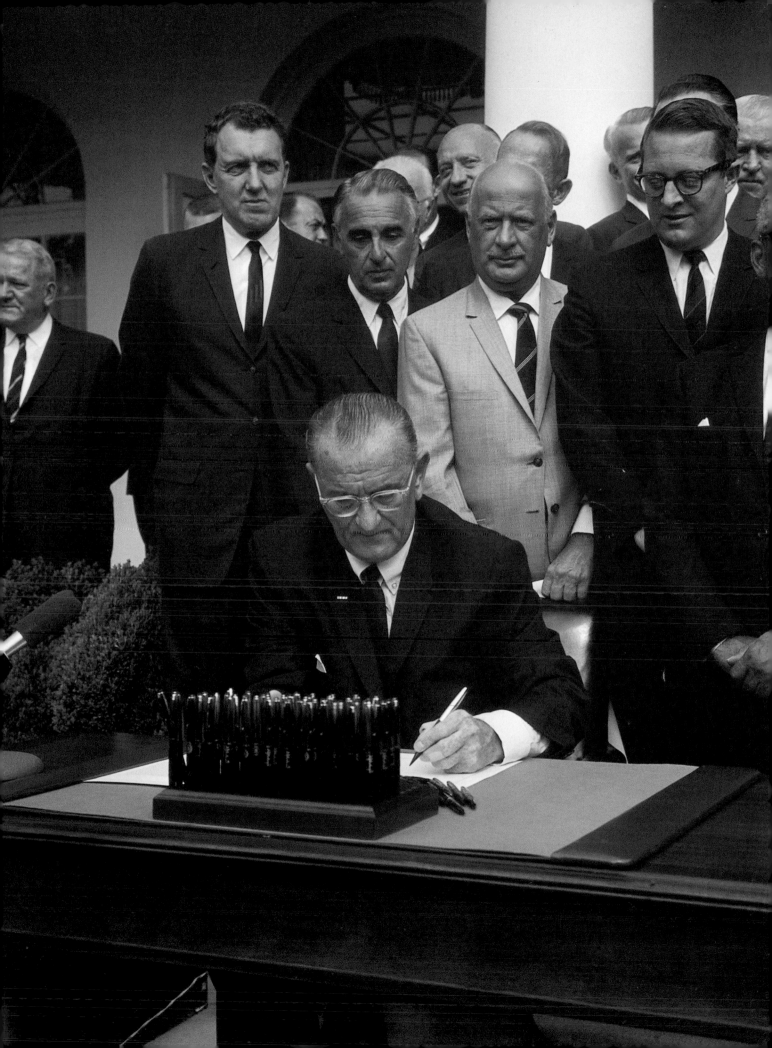

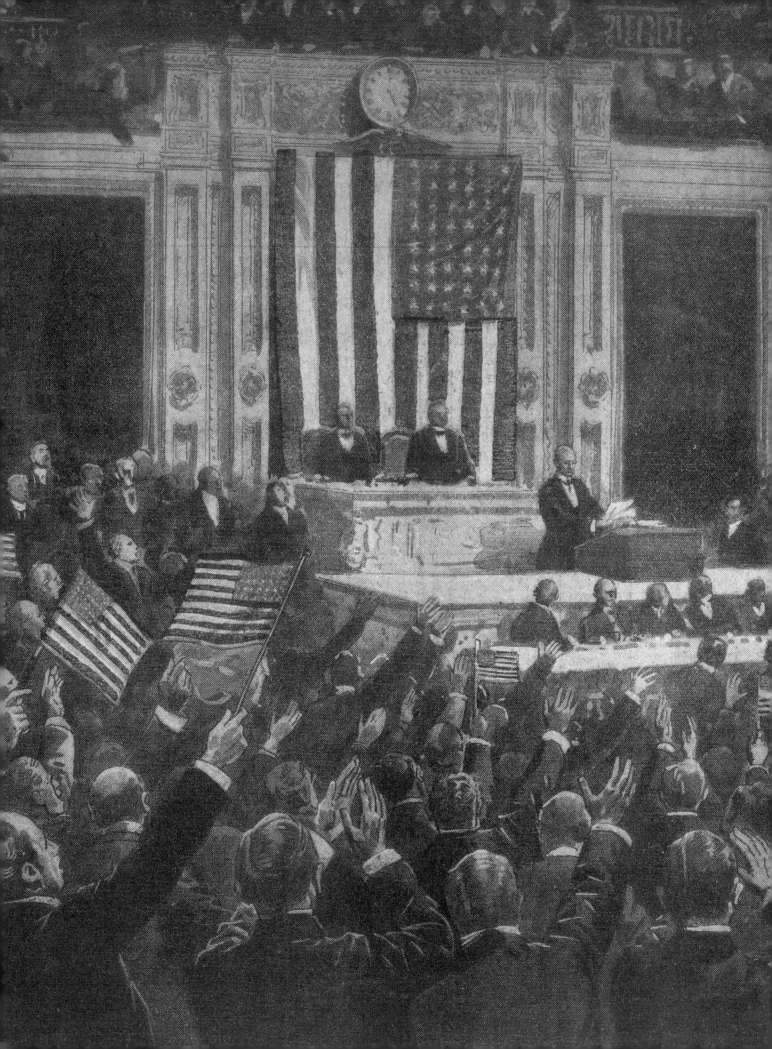

JOINT ADDRESS TO CONGRESS LEADING TO

A DECLARATION *of* WAR AGAINST GERMANY

Woodrow Wilson, 1917

It is a distressing and oppressive duty, Gentlemen of the Congress, which I have performed in thus addressing you. There are, it may be many months of fiery trial and sacrifice ahead of us. It is a fearful thing to lead this great peaceful people into war, into the most terrible and disastrous of all wars, civilization itself seeming to be in the balance.

But the right is more precious than peace, and we shall fight for the things which we have always carried nearest our hearts,—for democracy, for the right of those who submit to authority to have a voice in their own Governments, for the rights and liberties of small nations, for a universal dominion of right by such a concert of free peoples as shall bring peace and safety to all nations and make the world itself at last free. To such a task we can dedicate our [lives] and our fortunes, every thing that we are and everything that we have, with the pride of those who know that the day has come when America is privileged to spend her blood and her might for the principles that gave her birth and happiness and the peace which she has treasured. God helping her, she can do no other.

When hostilities broke out in Europe in 1914, President Woodrow Wilson declared America's intent to remain neutral, but events between 1915 and 1917 made that position untenable. Key among those events were the sinking of several ships by German submarines with resulting American deaths, and the Zimmermann Telegram. The telegram, written by the German foreign secretary, proposed a military alliance with Mexico against the United States. The British decoded the telegram, presenting it to Wilson on February 24, 1917. Wilson delivered his message to Congress on April 2.

OVER THERE

George M. Cohan, 1917

Johnnie get your gun,

Get your gun, get your gun,

Take it on the run,

On the run, on the run,

Hear them calling you and me,

Ev'ry son of liberty.

Hurry right away,

No delay, go today,

Make your daddy glad

To have had such a lad,

Tell your sweetheart not to pine,

To be proud her boy's in line.

(CHORUS sung twice)

Johnnie get your gun,

Get your gun, get your gun,

Johnnie show the Hun

You're a son-of-a-gun.

Hoist the flag and let her fly,

Yankee Doodle do or die.

Pack your little kit,

Show your grit, do your bit,

Yankees to the ranks

From the towns and the tanks,

Make your mother proud of you

And the old Red, White and Blue.

(CHORUS sung twice)

CHORUS

Over there, over there,

Send the word, send the word

over there

That the Yanks are coming,

The Yanks are coming,

The drums rum-tumming

Ev'rywhere.

So prepare, say a pray'r,

Send the word, send the word

to beware.

We'll be over, we're coming over,

And we won't come back till it's over

Over there!

George M. Cohan was the living definition of the patriotic American—confident his country was the best place on earth. He is remembered for his singing, composing, and Broadway shows, but is perhaps most beloved for the song "Over There." Written in 1917, the song was a symbolic bugle call, urging all Americans to join the fight for freedom and warning all the world to prepare for the courageous American forces.

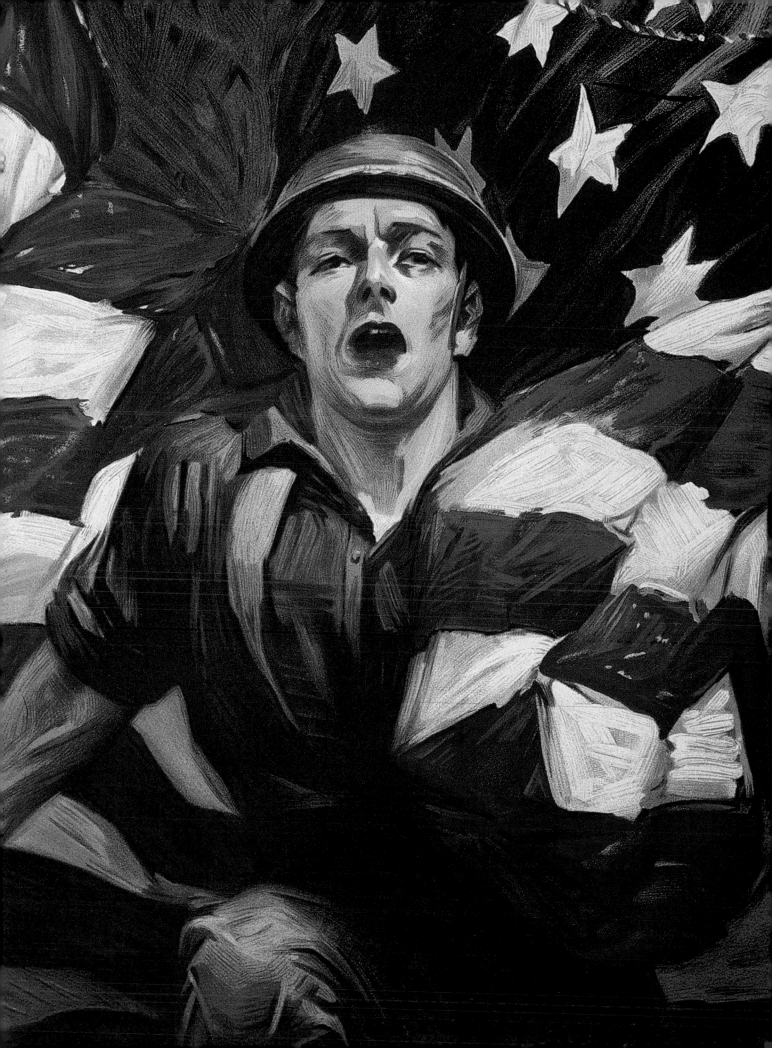

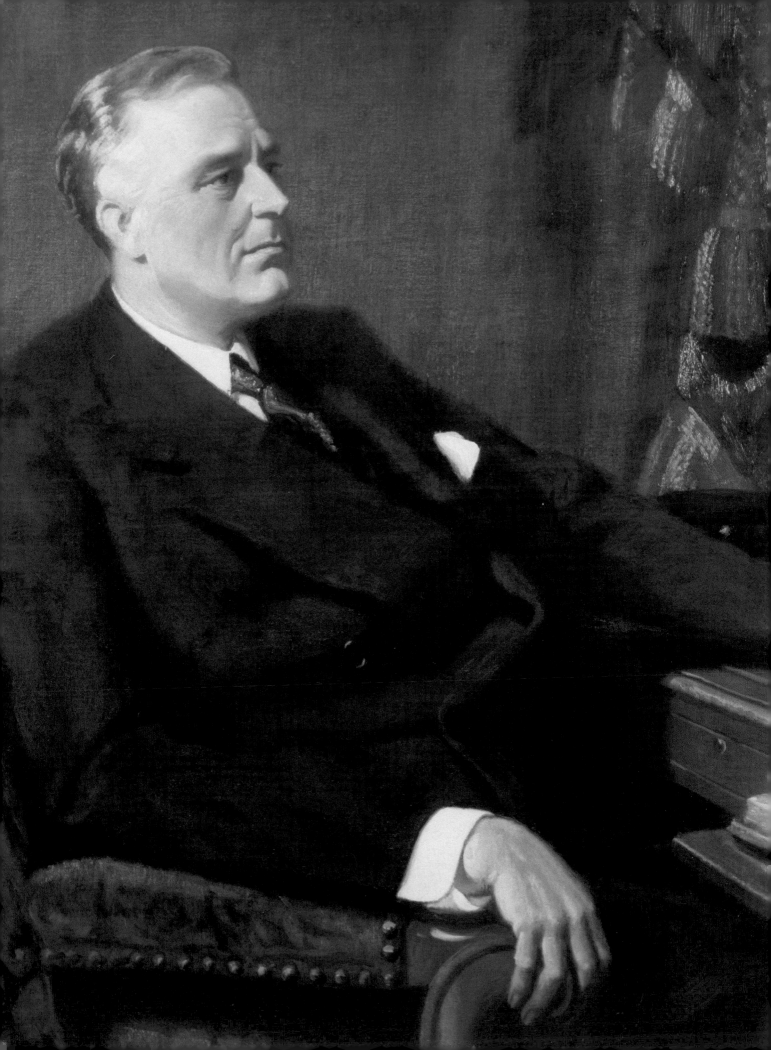

FIRST INAUGURAL ADDRESS

Franklin D. Roosevelt, 1933

This is preeminently the time to speak the truth, the whole truth, frankly and boldly. Nor need we shrink from honestly facing conditions in our country today. This great Nation will endure as it has endured, will revive and will prosper. So, first of all, let me assert my firm belief that the only thing we have to fear is fear itself—nameless, unreasoning, unjustified terror which paralyzes needed efforts to convert retreat into advance. In every dark hour of our national life a leadership of frankness and vigor has met with that understanding and support of the people themselves which is essential to victory. I am convinced that you will again give that support to leadership in these critical days.

Elected to the presidency four times, Franklin Delano Roosevelt served from 1933 to 1945 and led the American people through the Great Depression and the Second World War. When he took office in 1933, however, Roosevelt's greatest challenge was neither the economy nor national defense but the sagging confidence of the people. With his stirring speeches and comforting Fireside Chats, Roosevelt portrayed an image of a leader in full command of his office; he renewed the faith of Americans in their government and in themselves, preparing them to meet the great challenges of the day.

from THE FOUR FREEDOMS SPEECH

Franklin D. Roosevelt, 1941

As men do not live by bread alone, they do not fight by armaments alone. Those who man our defenses, and those behind them who build our defenses, must have the stamina and courage which come from an unshakable belief in the manner of life which they are defending. The mighty action that we are calling for cannot be based on a disregard of all things worth fighting for. . . .

In the future days, which we seek to make secure, we look forward to a world founded upon four essential human freedoms.

The first is freedom of speech and expression—everywhere in the world.

The second is freedom of every person to worship God in his own way—everywhere in the world.

The third is freedom from want—which, translated into world terms, means economic understandings which will secure to every nation a healthy peacetime life for its inhabitants—everywhere in the world.

The fourth is freedom from fear—which, translated into world terms, means a world-wide reduction of armaments to such a point and in such a thorough fashion that no nation will be in a position to commit an act of physical aggression against any neighbor—anywhere in the world.

That is no vision of a distant millennium. It is a definite basis for a kind of world attainable in our own time and generation. That kind of world is the very antithesis of the so-called new order of tyranny which the dictators seek to create with the crash of a bomb.

To that new order we oppose the greater conception—the moral order. A good society is able to face schemes of world domination and foreign revolutions alike without fear.

Since the beginning of our American history, we have been engaged in change—in a perpetual peaceful revolution—a revolution which goes on steadily, quietly adjusting itself to changing conditions—without the concentration camp or the quick-lime in the ditch. The world order which we seek is the cooperation of free countries, working together in a friendly, civilized society.

This nation has placed its destiny in the hands and heads and hearts of its millions of free men and women; and its faith in freedom under the guidance of God. Freedom means the supremacy of human rights everywhere. Our support goes to those who struggle to gain those rights or keep them. Our strength is our unity of purpose. To that high concept there can be no end save victory.

In his 1941 message to Congress, President Franklin D. Roosevelt enumerated four basic freedoms that he believed all people were entitled to. His words later inspired a series of paintings by Norman Rockwell.

JOINT ADDRESS TO CONGRESS LEADING TO

A DECLARATION *of* WAR AGAINST JAPAN

Franklin D. Roosevelt, 1941

Yesterday, December 7, 1941—a date which will live in infamy—the United States of America was suddenly and deliberately attacked by naval and air forces of the Empire of Japan.

The United States was at peace with that Nation and, at the solicitation of Japan, was still in conversation with its Government and its Emperor looking toward the maintenance of peace in the Pacific. Indeed, one hour after Japanese air squadrons had commenced bombing in the American Island of Oahu, the Japanese Ambassador to the United States and his colleague delivered to our Secretary of State a formal reply to a recent American message. And while this reply stated that it seemed useless to continue the existing diplomatic negotiations, it contained no threat or hint of war or of armed attack. . . .

Japan has, therefore, undertaken a surprise offensive extending throughout the Pacific area. The facts of yesterday and today speak for themselves. The people of the United States have already formed their opinions and well understand the implications to the very life and safety of our Nation.

As Commander in Chief of the Army and Navy I have directed that all measures be taken for our defense. . . .

No matter how long it may take us to overcome this premeditated invasion, the American people in their righteous might will win through to absolute victory. I believe that I interpret the will of the Congress and of the people when I assert that we will not only defend ourselves to the uttermost but will make it very certain that this form of treachery shall never again endanger us.

Hostilities exist. There is no blinking at the fact that our people, our territory, and our interests are in grave danger.

With confidence in our armed forces—with the unbounding determination of our people—we will gain the inevitable triumph- so help us God.

I ask that the Congress declare that since the unprovoked and dastardly attack by Japan on Sunday, December 7, 1941, a state of war has existed between the United States and the Japanese Empire.

At 12:30 PM on December 8, 1941, less than twenty-four hours after the Japanese attack on Pearl Harbor, President Roosevelt addressed a joint session of Congress with a request for a declaration of war. The Senate voted unanimously to support the request, while only one member of the House dissented. The declaration was signed into law that afternoon.

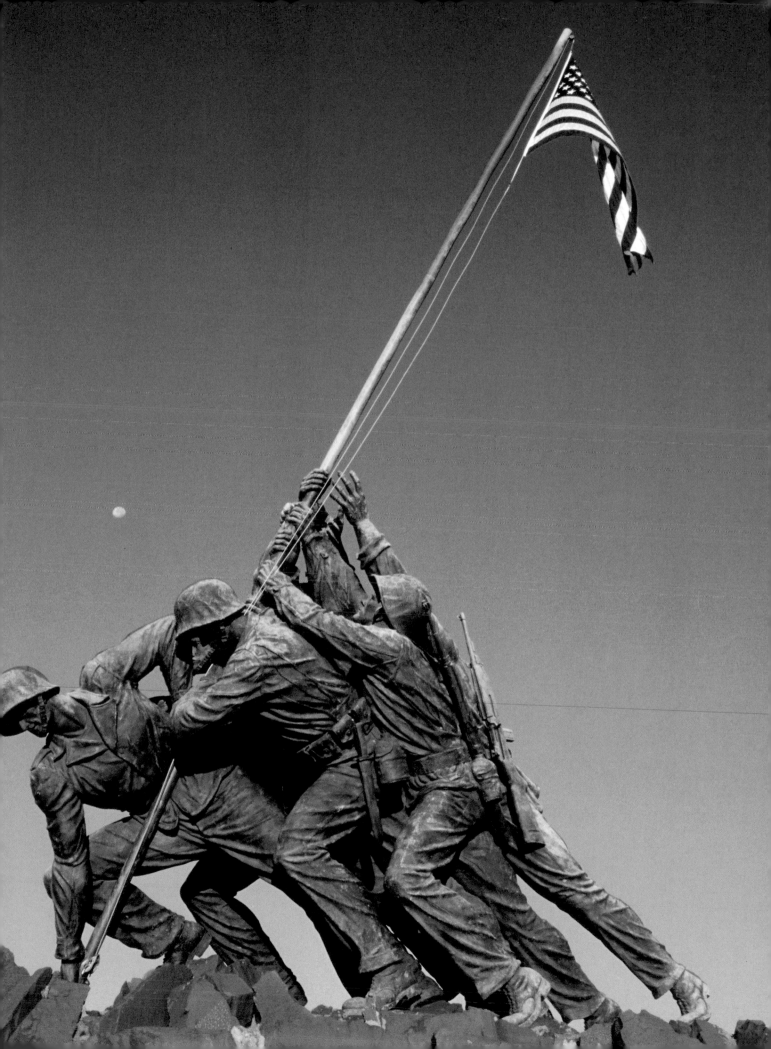

SPIRIT *of* LIBERTY

Judge Learned Hand, 1944

What then is the spirit of liberty? I cannot define it; I can only tell you of my own faith. The spirit of liberty is the spirit which is not too sure that it is right. The spirit of liberty is the spirit which seeks to understand the minds of other men and women. The spirit of liberty is the spirit which weighs their interests alongside its own without bias. The spirit of liberty remembers that not even a sparrow falls to earth unheeded. The spirit of liberty is the spirit of Him who, near two thousand years ago, taught mankind that lesson it has never learned, but has never quite forgotten: that there may be a kingdom where the least shall be heard and considered side by side with the greatest.

And now in that spirit, that spirit of an America which has never been, and which may never be; nay, which never will be, except as the conscience and courage of Americans create it; yet in the spirit of that America that lies hidden in some form in the aspirations of us all; in the spirit of that America for which our young are at this moment fighting and dying; in that spirit of liberty and of America I ask you to rise with me and to pledge our faith in the glorious destiny of our beloved country. . . .

Judge Learned Hand received his law degree from Harvard University before being appointed first to state and then federal courts. He was considered one of the finest jurists in American history and was a great defender of freedom of speech. Because his opinions were so well respected, he was called by some "the tenth justice of the Supreme Court." The above speech was delivered by Judge Hand at a patriotic rally in New York City in 1944. Almost from the moment the words were uttered, they have been frequently quoted.

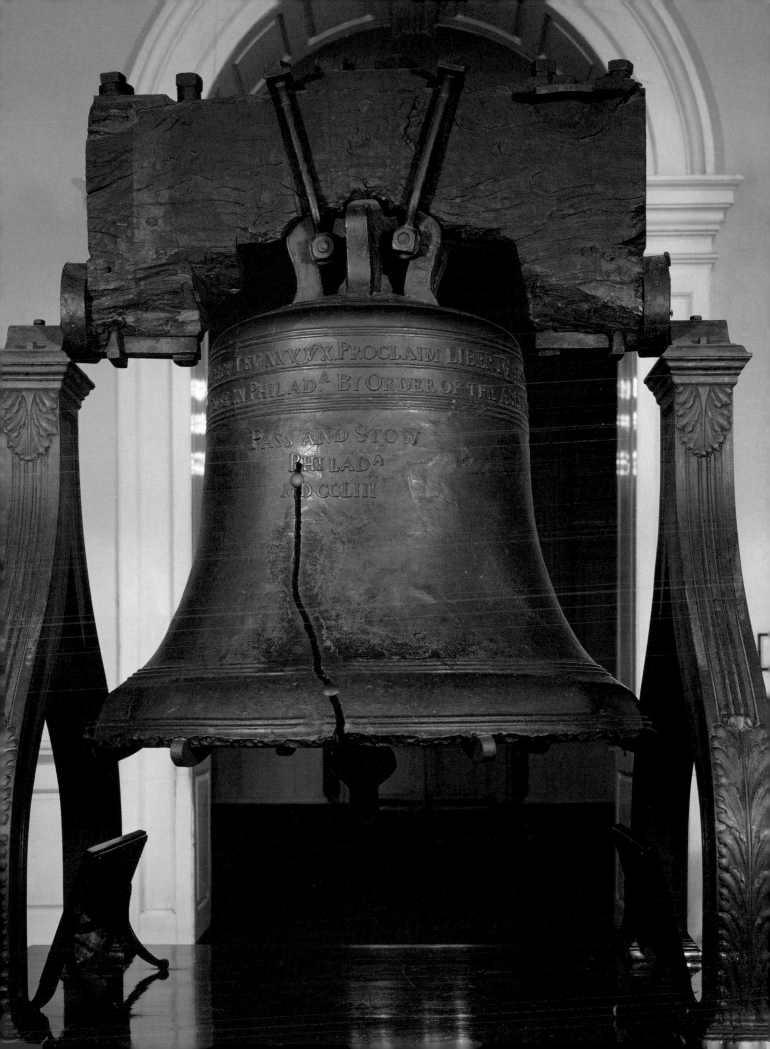

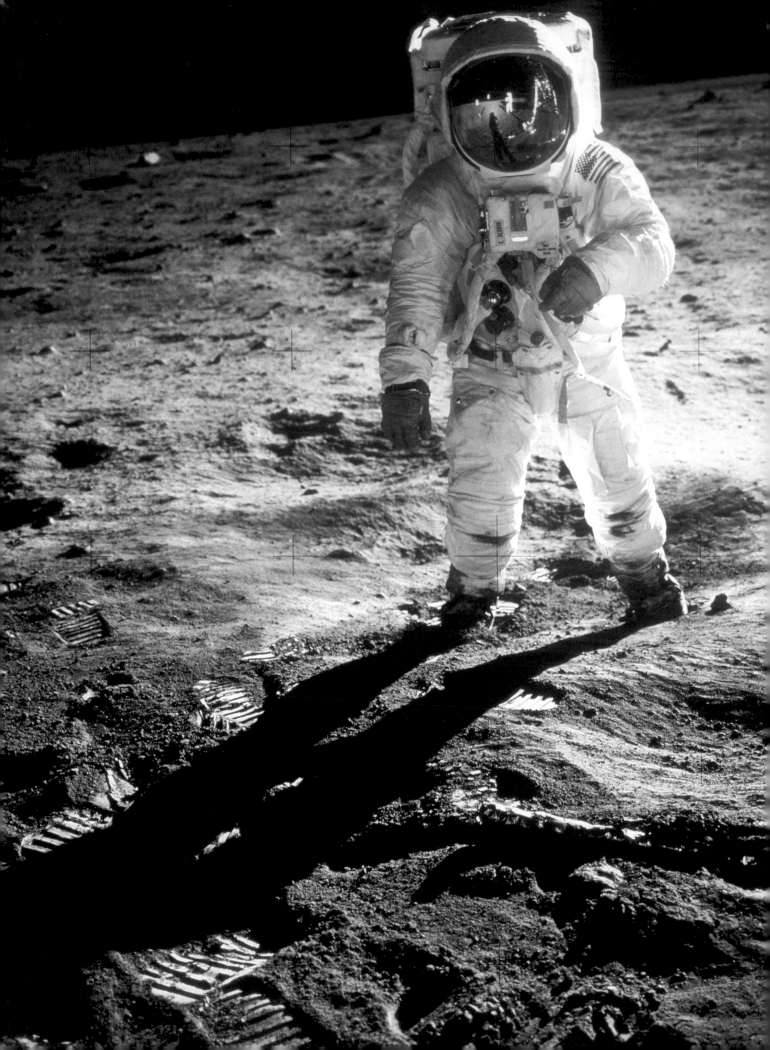

A Speech *to* Congress

John F. Kennedy, 1961

Now it is time to take longer strides—time for a great new American enterprise—time for this nation to take a clearly leading role in space achievement, which in many ways may hold the key to our future on earth. . . .

I believe that this nation should commit itself to achieving the goal, before this decade is out, of landing a man on the moon and returning him safely to the earth. No single space project in this period will be more impressive to mankind, or more important for the long-range exploration of space; and none will be so difficult or expensive to accomplish. . . .

Let it be clear—and this is a judgment which the Members of the Congress must finally make—let it be clear that I am asking the Congress and the country to accept a firm commitment to a new course of action. . . .

I believe we should go to the moon. . . .

Although many initially viewed with skepticism President John F. Kennedy's dream of sending a man to the moon, he was resolute in his conviction that the United States could and should land a man on the moon before the Soviet Union. Kennedy's vision guided the early space program as the Mercury, Gemini, and Apollo missions were being developed, and his dream was realized when Neil Armstrong stepped out of the Apollo 11 spacecraft and onto the surface of the moon.

REMARKS *at the* BERLIN WALL

John F. Kennedy, 1963

There are many people in the world who really don't understand, or say they don't, what is the great issue between the free world and the Communist world. Let them come to Berlin. There are some who say that communism is the wave of the future. Let them come to Berlin. And there are some who say in Europe and elsewhere we can work with the Communists. Let them come to Berlin. And there are even a few who say that it is true that communism is an evil system, but it permits us to make economic progress. *Lass' sie nach Berlin kommen.* Let them come to Berlin.

Freedom has many difficulties and democracy is not perfect, but we have never had to put a wall up to keep our people in, to prevent them from leaving us. . . . While the wall is the most obvious and vivid demonstration of the failures of the Communist system, for all the world to see, we take no satisfaction in it, for it is, as your Mayor has said, an offense not only against history but an offense against humanity, separating families, dividing husbands and wives and brothers and sisters, and dividing a people who wish to be joined together.

What is true of this city is true of Germany—real, lasting peace in Europe can never be assured as long as one German out of four is denied the elementary right of free men, and that is to make a free choice. In eighteen years of peace and good faith, this generation of Germans has earned the right to be free, including the right to unite their families and their nation in lasting peace, with good will to all people. . . . So let me ask you as I close, to lift your eyes beyond the dangers of today, to the hopes of tomorrow, beyond the freedom merely of this city of Berlin, or your country of Germany, to the advance of freedom everywhere, beyond the wall to the day of peace with justice, beyond yourselves and ourselves to all mankind.

Freedom is indivisible, and when one man is enslaved, all are not free. When all are free, then we can look forward to that day when this city will be joined as one and this country and this great Continent of Europe in a peaceful and hopeful globe. When that day finally comes, as it will, the people of West Berlin can take sober satisfaction in the fact that they were in the front lines for almost two decades.

All free men, wherever they may live, are citizens of Berlin, and, therefore, as a free man, I take pride in the words "*Ich bin ein Berliner.*"

In the summer of 1961, the East German government began erecting a barrier between East and West Berlin to stop the flow of defectors to West Germany. The wall would eventually surround all of West Berlin, cutting off access between the East Berliners and the West Germans. Shortly after the wall's completion in 1963, President Kennedy spoke at the Rudolph-Wilde-Platz, pledging that East Berliners would not be forgotten by the U.S.

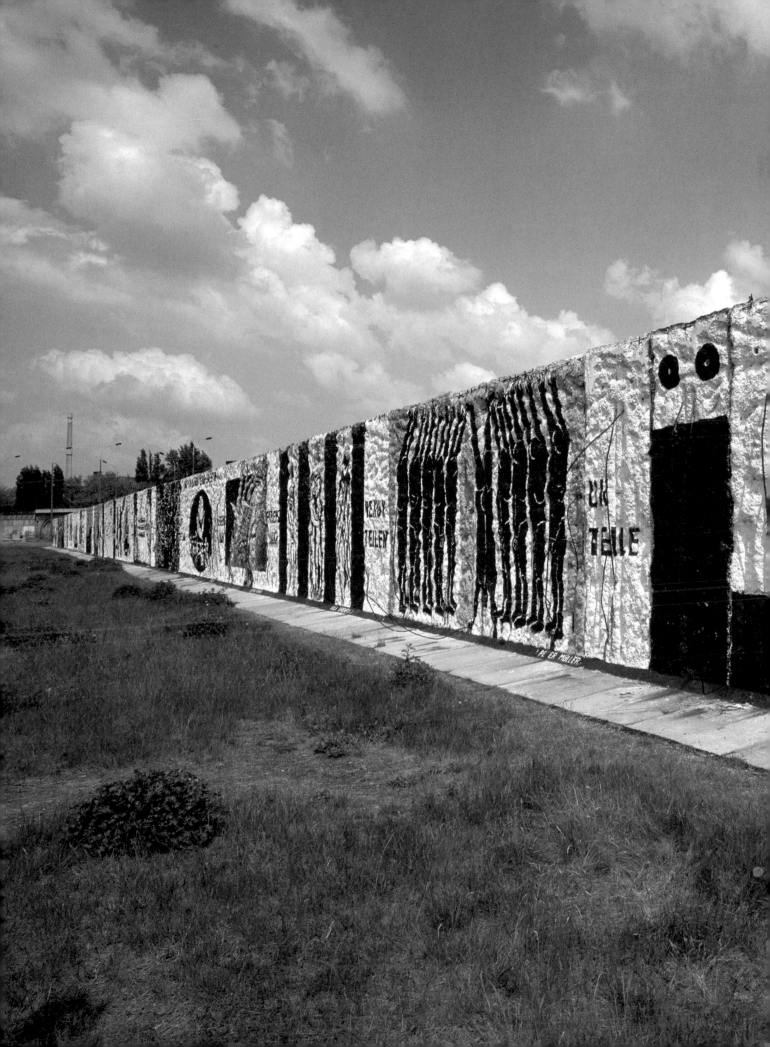

Address to the Congress
Space Exploration: A New Era

Colonel Edwin E. "Buzz" Aldrin, September 16, 1969

Distinguished ladies and gentlemen, it is with a great sense of pride as an American and with humility as a human being that I say to you today what no men have been privileged to say before: "We walked on the moon." But the footprints at Tranquility base belong to more than the crew of *Apollo 11*. They were put there by hundreds of thousands of people across this country, people in government, industry and universities, the teams and crews that preceded us, all who strived throughout the years with Mercury, Gemini, and Apollo.

Those footprints belong to the American people and you, their representatives, who accept it and support it, the inevitable challenge of the moon. And, since we came in peace for all mankind, those footprints belong also to all people of the world. As the moon shines impartially on all those looking up from our spinning earth, so do we hope the benefits of space exploration will be spread equally with a harmonizing influence to all mankind.

Scientific exploration implies investigating the unknown. The result can never be wholly anticipated. Charles Lindbergh said, "Scientific accomplishment is a path, not an end; a path leading to and disappearing in mystery."

Our steps in space have been a symbol of this country's way of life as we open our doors and windows to the world to view our successes and failures and as we share with all nations our discovery. The Saturn, *Columbia*, and *Eagle*, and the Extravehicular Mobility Unit have proved to Neil, Mike, and me that this nation can produce equipment of the highest quality and dependability. This should give all of us hope and inspiration to overcome some of the more difficult problems here on earth. The Apollo lesson is that national goals can be met where there is a strong enough will to do so.

The first step on the moon was a step toward our sister planets and ultimately toward the stars. "A small step for a man," was a statement of a fact; "a giant leap for mankind," is a hope for the future.

What this country does with the lessons of Apollo apply to domestic problems, and what we do in further space exploration programs will determine just how giant a leap we have taken.

On July 20, 1969, "Buzz" Aldrin and Neil Armstrong became the first two men to set foot on the moon. They were accompanied in the Apollo 11 *spacecraft by astronaut Michael Collins.*

ADDRESS *to the* NATION
on the CHALLENGER DISASTER

Ronald W. Reagan, 1986

Today is a day for mourning and remembering. Nancy and I are pained to the core by the tragedy of the shuttle *Challenger*. We know we share this pain with all of the people of our country. This is truly a national loss.

Nineteen years ago, almost to the day, we lost three astronauts in a terrible accident on the ground. But we've never lost an astronaut in flight; we've never had a tragedy like this. And perhaps we've forgotten the courage it took for the crew of the shuttle. But they, the Challenger Seven, were aware of the dangers, but overcame them and did their jobs brilliantly. We mourn seven heroes: Michael Smith, Dick Scobee, Judith Resnik, Ronald McNair, Ellison Onizuka, Gregory Jarvis, and Christa McAuliffe. We mourn their loss as a nation together.

For the families of the seven, we cannot bear, as you do, the full impact of this tragedy. But we feel the loss, and we're thinking about you so very much. Your loved ones were daring and brave, and they had that special grace, that special spirit that says, "Give me a challenge, and I'll meet it with joy." They had a hunger to explore the universe and discover its truths. They wished to serve, and they did. They served all of us. . . .

I've always had great faith in and respect for our space program, and what happened today does nothing to diminish it. We don't hide our space program. We don't keep secrets and cover things up. We do it all up front and in public. That's the way freedom is, and we wouldn't change it for a minute. We'll continue our quest in space. There will be more shuttle flights and more shuttle crews and, yes, more volunteers, more civilians, more teachers in space. Nothing ends here; our hopes and our journeys continue. . . .

There's a coincidence today. On this day 390 years ago, the great explorer Sir Francis Drake died aboard ship off the coast of Panama. In his lifetime the great frontiers were the oceans, and an historian later said, "He lived by the sea, died on it, and was buried in it." Well, today we can say of the *Challenger* crew: Their dedication was, like Drake's, complete.

The crew of the space shuttle *Challenger* honored us by the manner in which they lived their lives. We will never forget them, nor the last time we saw them, this morning, as they prepared for their journey and waved goodbye and "slipped the surly bonds of earth" to "touch the face of God."

On January 28, 1986, the Challenger *exploded just moments after launch. All seven crew members died, including Christa McAuliffe, the first civilian and first teacher to go into space. The tragedy was witnessed by millions as they watched the launch on television.*

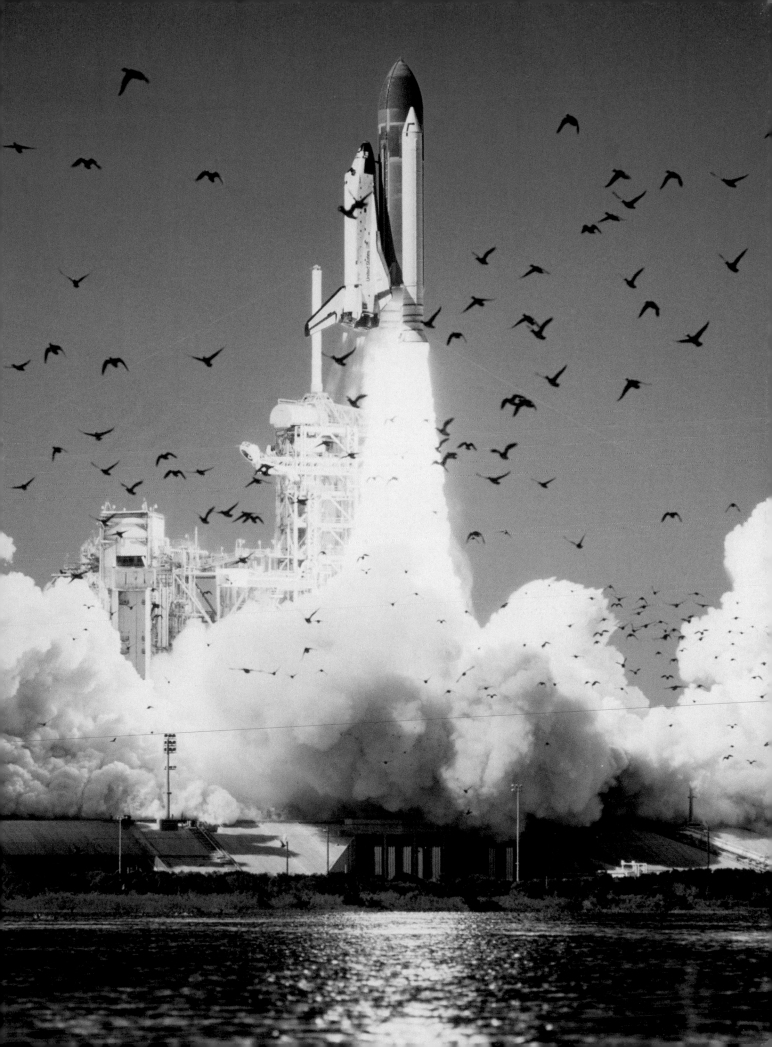

TEAR DOWN *this* WALL

Ronald W. Reagan, 1987

Behind me stands a wall that encircles the free sectors of this city, part of a vast system of barriers that divides the entire continent of Europe. From the Baltic, south, those barriers cut across Germany in a gash of barbed wire, concrete, dog runs, and guard towers. Farther south, there may be no visible, no obvious wall. But there remain armed guards and checkpoints all the same—still a restriction on the right to travel, still an instrument to impose upon ordinary men and women the will of a totalitarian state. Yet it is here in Berlin where the wall emerges most clearly; here, cutting across your city, where the news photo and the television screen have imprinted this brutal division of a continent upon the mind of the world. Standing before the Brandenburg Gate, every man is a German, separated from his fellow men. Every man is a Berliner, forced to look upon a scar. . . .

In the 1950s, Khrushchev predicted: "We will bury you." But in the West today, we see a free world that has achieved a level of prosperity and well-being unprecedented in all human history. In the Communist world, we see failure, technological backwardness, declining standards of health, even want of the most basic kind—too little food. Even today, the Soviet Union still cannot feed itself. After these four decades, then, there stands before the entire world one great and inescapable conclusion: Freedom leads to prosperity. Freedom replaces the ancient hatreds among the nations with comity and peace. Freedom is the victor. . . .

Are these the beginnings of profound changes in the Soviet state? Or are they token gestures, intended to raise false hopes in the West, or to strengthen the Soviet system without changing it? We welcome change and openness; for we believe that freedom and security go together, that the advance of human liberty can only strengthen the cause of world peace. There is one sign the Soviets can make that would be unmistakable, that would advance dramatically the cause of freedom and peace.

General Secretary Gorbachev, if you seek peace, if you seek prosperity for the Soviet Union and Eastern Europe, if you seek liberalization: Come here to this gate! Mr. Gorbachev, open this gate! Mr. Gorbachev, tear down this wall! . . .

In 1987, President Ronald Reagan visited the Berlin Wall—twenty-four years after John F. Kennedy's memorable visit. Two years later, in 1989, the dismantling of the wall began, and by October 1990, as East Germany was reabsorbed into the Federal Republic of Germany, only short sections of the wall remained.

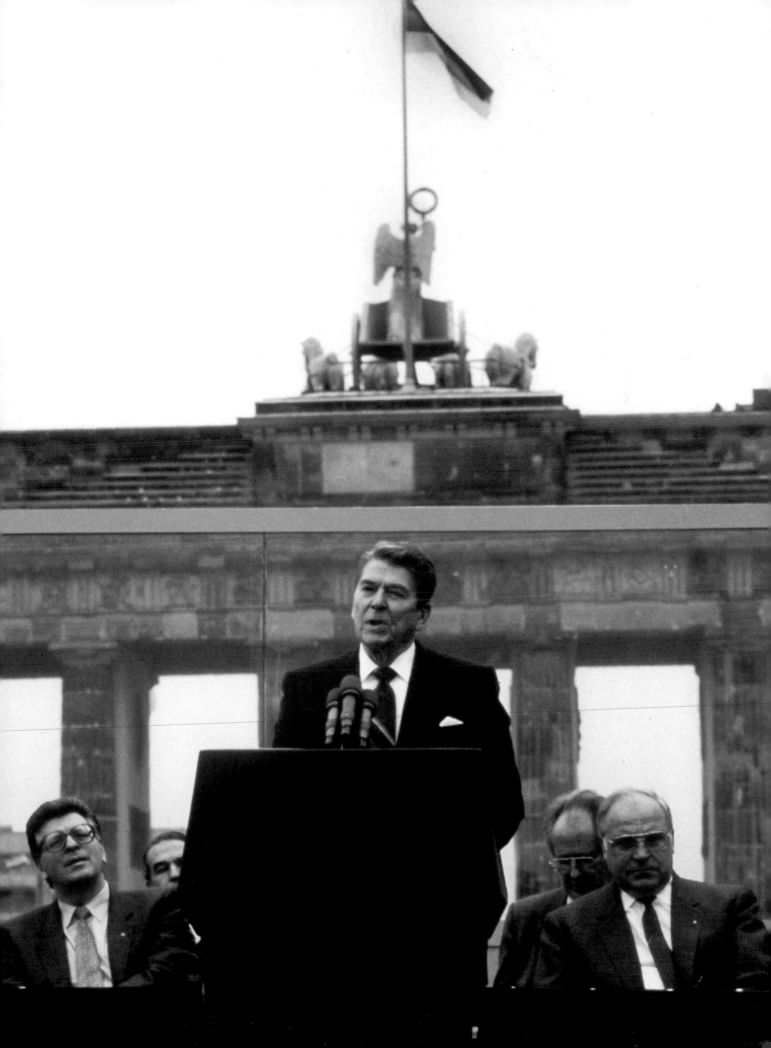

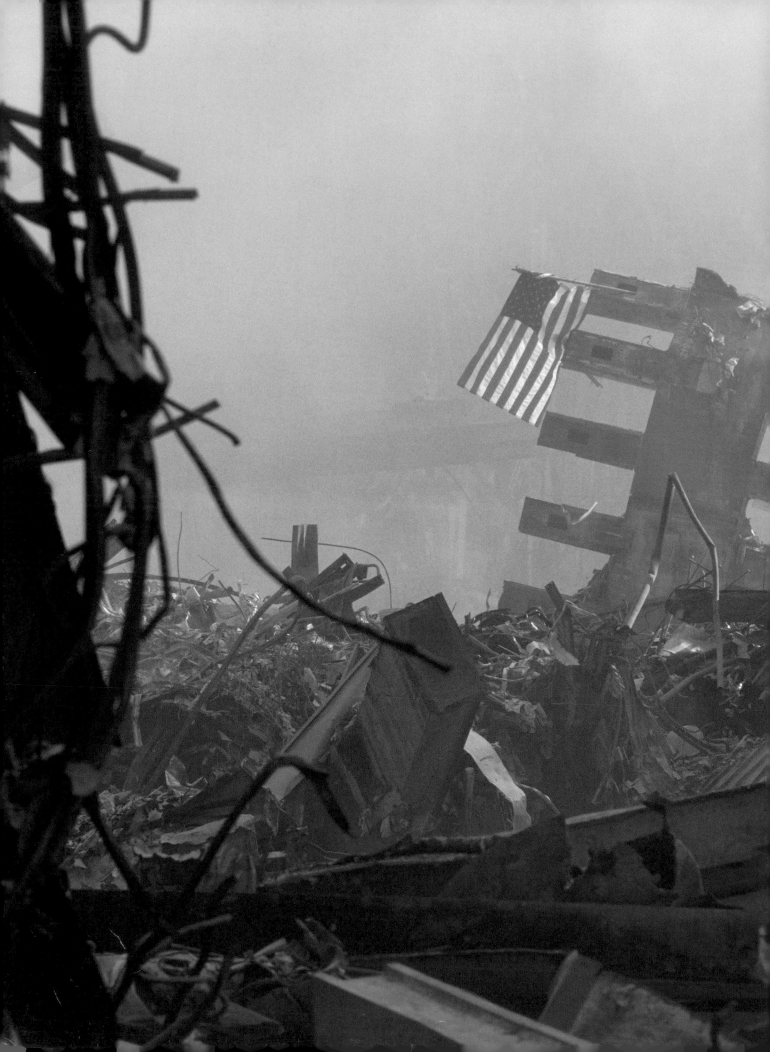

STATEMENT *by the* PRESIDENT *in* HIS ADDRESS *to the* NATION

George W. Bush, 2001

Today, our fellow citizens, our way of life, our very freedom came under attack in a series of deliberate and deadly terrorist acts. The victims were in airplanes, or in their offices; secretaries, businessmen and women, military and federal workers; moms and dads, friends and neighbors. Thousands of lives were suddenly ended by evil, despicable acts of terror.

The pictures of airplanes flying into buildings, fires burning, huge structures collapsing, have filled us with disbelief, terrible sadness, and a quiet, unyielding anger. These acts of mass murder were intended to frighten our nation into chaos and retreat. But they have failed; our country is strong.

A great people has been moved to defend a great nation. Terrorist attacks can shake the foundations of our biggest buildings, but they cannot touch the foundation of America. These acts shattered steel, but they cannot dent the steel of American resolve.

America was targeted for attack because we're the brightest beacon for freedom and opportunity in the world. And no one will keep that light from shining.

Today, our nation saw evil, the very worst of human nature. And we responded with the best of America—with the daring of our rescue workers, with the caring for strangers and neighbors who came to give blood and help in any way they could. . . .

America and our friends and allies join with all those who want peace and security in the world, and we stand together to win the war against terrorism. Tonight, I ask for your prayers for all those who grieve, for the children whose worlds have been shattered, for all whose sense of safety and security has been threatened. And I pray they will be comforted by a power greater than any of us, spoken through the ages in Psalm 23: "Even though I walk through the valley of the shadow of death, I fear no evil, for You are with me."

This is a day when all Americans from every walk of life unite in our resolve for justice and peace. America has stood down enemies before, and we will do so this time. None of us will ever forget this day. Yet, we go forward to defend freedom and all that is good and just in our world.

Thank you. Good night, and God bless America.

When September 11, 2001, dawned clear and bright, few could imagine the horrific turn the day would take as terrorist attacks destroyed the Twin Towers of the World Trade Center in Manhattan, collapsed parts of the Pentagon near Washington DC, and brought a jetliner down in a fiery crash in rural Pennsylvania. Thousands of American lives were lost, and the repercussions of the attacks will continue to be felt by generations to come.

from SILENT SPRING

Rachel Carson, 1962

It took hundreds of millions of years to produce the life that now inhabits the earth—eons of time in which that developing and evolving and diversifying life reached a state of adjustment and balance within its surroundings. The environment, rigorously shaping and directing the life it supported, contained elements that were hostile as well as supporting. Certain rocks gave out dangerous radiation; even within the light of the sun, from which all life draws its energy, there were short-wave radiations with power to injure. Given time—time not in years but in millenia—life adjusts, and a balance has been reached. For time is the essential ingredient; but in the modern world there is no time.

The rapidity of change and the speed with which new situations are created follow the impetuous and heedless pace of man rather than the deliberate pace of nature. Radiation is no longer merely the background radiation of rocks, the bombardment of cosmic rays, the ultraviolet of the sun that have existed before there was any life on earth; radiation is now the unnatural creation of man's tampering with the atom. The chemicals to which life is asked to make its adjustment are no longer merely the calcium and silica and copper and all the rest of the minerals washed out of the rocks and carried in rivers to the sea; they are the synthetic creations of man's inventive mind,

brewed in his laboratories, and having no counterparts in nature.

To adjust to these chemicals would require time on the scale that is nature's; it would require not merely the years of a man's life but the life of generations. And even this, were it by some miracle possible, would be futile, for the new chemicals come from our laboratories in an endless stream; almost five hundred annually find their way into actual use in the United States alone. The figure is staggering and its implications are not easily grasped—500 new chemicals to which the bodies of men and animals are required somehow to adapt each year, chemicals totally outside the limits of biologic experience. . . .

These sprays, dusts, and aerosols are now applied almost universally to farms, gardens, forests, and homes—nonselective chemicals that have the power to kill every insect, the "good" and the "bad," to still the song of birds and the leaping of fish in the streams, to coat the leaves with a deadly film, and to linger on in soil—all this though the intended target may be only a few weeds or insects. Can anyone believe it is possible to lay down such a barrage of poisons on the surface of the earth without making it unfit for all life? They should not be called "insecticides," but "biocides." . . .

The "control of nature" is a phrase conceived in arrogance, born of the Neanderthal age of biology

and philosophy, when it was supposed that nature exists for the convenience of man. The concepts and practices of applied entomology for the most part date from that Stone Age of science. It is our alarming misfortune that so primitive a science has armed itself with the most modern and terrible weapons, and that in turning them against the insects it has also turned them against the earth.

Rachel Carson subscribed to the belief that human beings are simply one part of nature, and that we must be responsible for the effects of our actions on the rest of the ecosystem. Her early work, both as scientist and writer, centered on communicating the wonder of nature. In Silent Spring, she changed her focus to warn of the environmental dangers of the long-term use of pesticides. She testified before Congress on the topic in 1963, despite the criticism of those who claimed she was an alarmist. Carson's work awakened millions to the environmental movement and her impact continues to be felt today.

THE AMERICAN IDEA

Theodore H. White, 1986

The idea was there at the very beginning, well before Thomas Jefferson put it into words—and the idea rang the call.

Jefferson himself could not have imagined the reach of his call across the world in time to come when he wrote:

"We hold these truths to be self-evident, that all men are created equal, that they are endowed by their Creator with certain unalienable rights, that among these are life, liberty and the pursuit of happiness."

But over the next two centuries the call would reach the potato patches of Ireland, the ghettoes of Europe, the paddyfields of China, stirring farmers to leave their lands and townsmen their trades and thus unsettling all traditional civilizations.

It is the call from Thomas Jefferson, embodied in the great statue that looks down the Narrows of New York Harbor, and in the immigrants who answered the call, that we now celebrate.

Some of the first European Americans had come to the new continent to worship God in their own way, others to seek their fortunes. But over a century-and-a-half, the new world changed those Europeans, above all the Englishmen who had come to North America. Neither King nor Court nor church could stretch over the ocean to the wild continent. To survive, the first emigrants had to learn to govern themselves. But the freedom of the wilderness whetted their appetites for more freedoms. By the time Jefferson drafted his call, men were in the field fighting for those new-learned freedoms, killing and being killed by English soldiers, the best-trained troops in the world, supplied by the world's greatest navy. Only something worth dying for could unite American volunteers and keep them in the field—a stated cause, a flag, a nation they could call their own.

When, on the Fourth of July, 1776, the colonial leaders who had been meeting as a Continental Congress in Philadelphia voted to approve Jefferson's Declaration of Independence, it was not puffed-up rhetoric for them to pledge to each other "our lives, our fortunes and our sacred honor." Unless their new "United States of America" won the war, the Congressmen would be judged traitors as relentlessly as would the irregulars-under-arms in the field. And all knew what English law allowed in the case of a traitor. The victim could be partly strangled; drawn, or disemboweled, while still alive, his entrails then burned and his body quartered.

The new Americans were tough men fighting for a very tough idea. How they won their battle is a story for the schoolbooks, studied by scholars, wrapped in myths by historians and poets.

But what is most important is the story of the idea that made them into a nation, the idea that had an explosive power undreamed of in 1776.

All other nations had come into being among

people whose families had lived for time out of mind on the same land where they were born. Englishmen are English, Frenchmen are French, Chinese are Chinese, while their governments come and go; their national states can be torn apart and remade without losing their nationhood. But Americans are a nation born of an idea; not the place, but the idea, created the United States Government.

"The American Idea" is an unfinished article by Theodore H. White to commemorate the bicentennial of the United States. His words remind us that what holds us together as a nation is our heritage—a heritage of ideas and beliefs, a heritage to which we can turn for inspiration and guidance in times of challenge.

INDEX

Address to the Nation on the *Challenger* Disaster
 (Ronald W. Reagan), 70
Address to the Ohio Women's Rights Convention
 (Sojourner Truth), 40
Aldrin, Colonel Edwin E., 69
America the Beautiful, 36
American Idea, The, 78–79
Anthony, Susan B., 42
Bates, Katharine Lee, 36
Battle Hymn of the Republic, The, 22
Bill of Rights, The, 12–13
Bradford, William, 5
Brown v. Board of Education, 46–47
Bush, George W., 75
Carson, Rachel, 76–77
Chief Seattle, 32–33
Civil Rights Act of 1964, 50
Cohan, George M., 54
Common Sense, 11
Constitution of the United States of
 America, The, 12–13
Declaration of Independence of the
 United States of America, 8
Declaration of War Against Germany, A, 53
Declaration of War Against Japan, A, 60
Douglass, Frederick, 21
Emancipation Proclamation, 26
Farewell Address (George Washington), 14–15
First Inaugural Address (Franklin D. Roosevelt), 57
Four Freedoms Speech, The, 58
Gettysburg Address, The, 25
Grant, Ulysses S., 29
Hand, Judge Learned, 62
Henry, Patrick, 6
Homestead Act, The, 35
"A House Divided" speech, 18

Howe, Julia Ward, 22
"I Have a Dream" speech, 48–49
Inaugural Address (John F. Kennedy), 45
Independence Day Speech (Frederick Douglass), 21
"Is It a Crime to Vote?" speech, 42
Kennedy, John F., 45, 65, 66
Key, Francis Scott, 17
King Jr., Martin Luther, 48–49
Lazarus, Emma, 39
Lewis and Clark Expedition, The, 30
Lewis, Meriwether, 30
Lincoln, Abraham, 18, 25, 26
Mayflower Compact, The, 5
New Colossus, The, 39
Oration, The, 32–33
Over There, 54
Paine, Thomas, 11
Pledge of Allegiance, The, 3
Reagan, Ronald W., 70, 72
Remarks at the Berlin Wall, 66
Roosevelt, Franklin D., 57, 58, 60
Silent Spring, 76–77
Space Exploration: A New Era, 69
Speech to Congress (John F. Kennedy), 65
Speech to the Second Virginia Convention
 (Patrick Henry), 6
Spirit of Liberty, 62
Star-Spangled Banner, The, 17
Statement by the President in His Address to the
 Nation (George W. Bush), 75
Surrender of General Robert E. Lee, The, 29
"Tear Down this Wall" speech, 72
Truth, Sojourner, 40
Washington, George, 14–15
White, Theodore H., 78–79
Wilson, Woodrow, 53